IMAGES
of America

RAILROADS OF THE
PIKE'S PEAK REGION
1870–1900

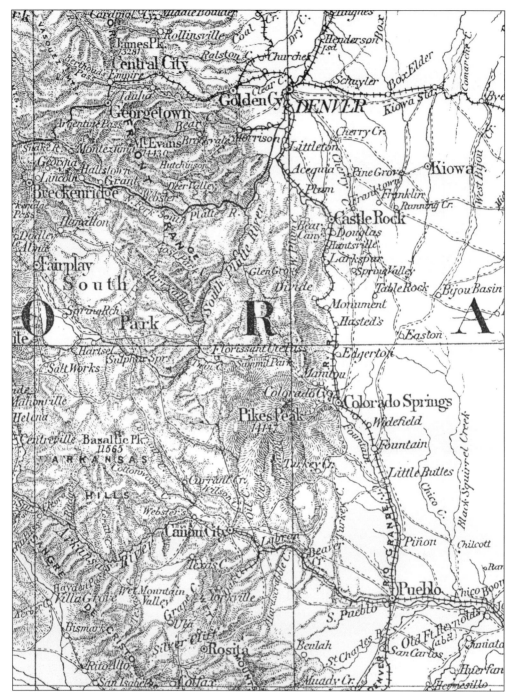

This 1879 map shows the Denver & Rio Grande Railway as it followed the mountains of Colorado's Front Range from Denver through Colorado Springs to Pueblo. In another year the Manitou Branch would be completed. At this time Colorado Springs had only one rail connection, but it would not remain that way for long. By the end of the 19th century, the Pike's Peak Region would be served by half a dozen railroads.

IMAGES
of America

RAILROADS OF THE
PIKE'S PEAK REGION
1870–1900

Allan C. Lewis

ARCADIA

Published by Arcadia Publishing
Charleston SC, Chicago IL, Portsmouth NH, San Francisco CA

Printed in Great Britain

Library of Congress Catalog Card Number: 2004101548

For all general information contact Arcadia Publishing at:
Telephone 843-853-2070
Fax 843-853-0044
E-mail sales@arcadiapublishing.com
For customer service and orders:
Toll-Free 1-888-313-2665

Visit us on the internet at http://www.arcadiapublishing.com

This book is dedicated to the memory of my father, Gilbert A. Lewis (1934–2004).

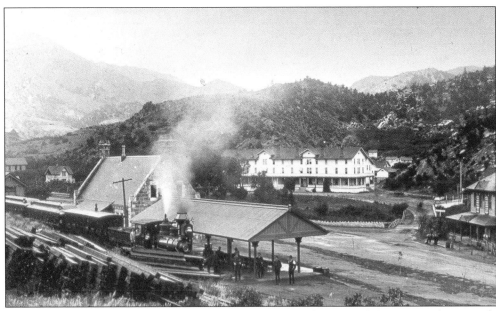

By the mid-1880s, the D&RG facilities at Manitou included a covered platform on the east side of the depot and (on the extreme left edge of the photograph) a freight depot. During the winter months, the D&RG made four trips a day between Colorado Springs and Manitou. In the summer, two more trains were added. (Photo by William H. Jackson.)

CONTENTS

Acknowledgments 6

Introduction 7

1. Origins 9

2. Denver & Rio Grande 19

3. Denver & New Orleans 31

4. Denver & Santa Fe 43

5. Colorado Midland 57

6. Chicago, Kansas & Nebraska 67

7. Manitou & Pike's Peak 79

8. Colorado Springs Rapid Transit 91

9. Excursion to Palmer Lake 101

10. Railroads of Early Cripple Creek 117

ACKNOWLEDGMENTS

While a majority of the efforts entailed in the assembly of this book were shouldered by the author, this project would not have been possible without the aid of friends and family. First and foremost, I would like to thank my wife Pam and son Joey. Their understanding afforded me the time needed for in-depth research, image acquisition, and assembly.

In addition, I am blessed with a wonderful group of friends: Steve Rasmussen, James R. "Jim" Jones, P.R. "Bob" Griswold, Bill and Sue Knous, Doug Summer, Frank Polzin, and Joe Moore. Their interest in preserving the history of Colorado railroads has fueled my own enthusiasm and I am greatly appreciative of the support they have shown.

The Local History Department of the Pike's Peak Library District was of great help. The friendly staff there provided access to a wealth of antiquarian directories and other local resources. I am also greatly indebted to the late Jackson "Jack" Thode and the late Ernie Peyton. For many years Jack and Ernie shared their vast knowledge of railroading with me and graciously served as mentors. Their presence in my life is sorely missed and it is my hope that this work is a fitting tribute to their friendship.

This book is not intended to be an exhaustive history of the railroads in the Colorado Springs area. Instead, it takes a topical approach in illustrating how the Pike's Peak Region grew as a result of its association with local railroads and the men who built and operated them. Using rare images and artifacts, this book revisits the romance and intrigue of 19th-century commerce and travel in an attempt to preserve the pioneering spirit of a bygone era.

Unless otherwise noted, all photos are from the author's collection.

INTRODUCTION

In October 1871, the narrow-gauged Denver & Rio Grande Railway arrived in Colorado Springs. It was immediately heralded as a success and was continued to Pueblo early the following year. General Palmer and his diminutive railroad ushered in a new era in the Pike's Peak Region. Serving the former territorial capitol of Colorado City, as well as the newly established town of Colorado Spring and the budding resort community of Manitou, the railroad provided swift and economical transportation, communication with the outside world, and economic prosperity for the communities it served.

In the years that followed, other railroads came to Colorado Springs. Former governor John Evans envisioned a railroad that would connect Denver to the Gulf Coast of Texas. The reality of this vision saw the establishment of the Denver & New Orleans Railroad. The road was built to Pueblo before financial difficulties ensued and, despite a branch line to Colorado Springs and the assistance of master railroad engineer Grenville Dodge, the railroad could not overcome a traffic deficit. After several reorganizations, the D&NO would eventually fall under the control of the Union Pacific.

After the Atchison, Topeka & Santa Fe Railway failed to secure the Royal Gorge, it turned an eye to the ripe market of Denver. Unsatisfied with trackage rights over the D&RG from Pueblo and thwarted in its efforts to buy the D&NO, in 1887 the AT&SF proposed to build its own tracks to Denver. The construction company tasked with completing this line was called the Denver & Santa Fe Railway Company. In many places, the projected route of the D&SF paralleled the D&RG and, upon its completion, a thriving Colorado Springs now had railroads on its eastern and western borders.

At about the same time the Santa Fe was building north from Pueblo, another railroad began to take shape. The Colorado Midland Railway proposed to build a standard-gauge railroad from the plains of the Front Range to the silver mines of Leadville, Apsen and beyond. A large parcel of ground was purchased just south of Colorado City where a roundhouse, company offices and car shops were established. Soon after, arrangements were made with the AT&SF, which saw the Santa Fe's Colorado Springs depot serve as the eastern terminus of the Colorado Midland. By the early 1890s, the Santa Fe had gained control of the Colorado Midland and finally had its access to Leadville and Central Colorado's mountainous interior.

By the late 1880s, Colorado Springs was home to three north-south railroads, but it still lacked a direct connection to the East. This dilemma was solved by the Chicago, Kansas & Nebraska, a subsidiary of the Chicago, Rock Island & Pacific Railway. The CK&N was a construction company chartered to build a series of extensions from central Kansas into Nebraska, Colorado, and Indian Territory (Oklahoma). Unlike the D&SF, which reverted to the Santa Fe soon after the tracks to Denver were completed, for a few years the CK&N was a viable railroad until it was absorbed by the Rock Island System in 1891.

Smaller roads would also be built. For decades tourists had ascended Pike's Peak on foot, by burro, and in carriage. In 1889, spurred on by mattress magnate Zalmon Simmons, a group of businessmen incorporated the Manitou & Pike's Peak Railroad and set out to build a railroad. Owing to the steep incline, the railroad incorporated a geared center rail that helped its unique

steam engines ascend the 14,110-foot mountain.

By 1890, although the several railroads were helping to move people and freight to and from Colorado Springs, the need for adequate public transportation within the Pike's Peak Region was a growing concern. Initially, horse-drawn trolleys came into use, but they were soon replaced by the faster electric cars of the Colorado Springs Rapid Transit Railway. The CSRT quickly set about erecting miles of trolley wires and connecting the towns of Colorado Springs, Colorado City, and Manitou, as well as some of the more distant communities of Knob Hill, Roswell, and The Broadmoor.

Throughout the 1890s, the Pike's Peak Region continued to grow. One of the major catalysts for this growth was the discovery of gold in Cripple Creek. Now the wealth of Colorado Springs was not just the result of an influx of Eastern Bluebloods. As the mines of Cripple Creek were developed, so was the supporting industry. Also established during this period were Cripple Creek's first two railroads, the Florence & Cripple Creek and the Midland Terminal. The resulting economic boom in Cripple Creek brought more jobs, more tourists and even more railroads. With the approach of the 20th century, Colorado Springs became a labyrinth of rail. With these rails had come unprecedented change. In 30 years, the Pike's Peak Region had been transformed from an unsettled prairie into a showcase where modern industry and technology combined with the natural beauty of the environment to form one of the most popular destinations in the country.

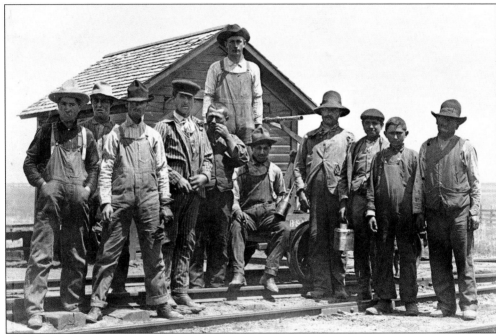

Building a railroad was a costly endeavor, but even after completion, the right-of-way still needed to be maintained. The sustaining effort of routine maintenance was the responsibility of the section crew. This 1890s view shows a section crew in Eastern Colorado gathered around a handcar shed taking a lunch break. While being a section man was hardly a glamorous aspect of railroading, workers like these kept trains running safely and on time.

One
ORIGINS

The westward expansion into the Pike's Peak Region began in the late 1850s. Along with their meager processions, these merchants, farmers, and miners brought dreams of new opportunity. A decade later, the territory of Colorado was now the destination of thousands whose stagecoach journey brought them across the vast expanse that separated the "Civilized East" from the "Wild West." For many, the towering projection of Pike's Peak epitomized the spirit of colonization, and it would be to this point that many settlers would gravitate. In the shadows of what would later be called "America's Mountain," the towns of Colorado City, Manitou, and Colorado Springs were established. By the 1870s, what had once been a procession of transient miners in wagons had become a new breed of pioneer, traveling over an unprecedented mode of transportation—the railroad. This quantum improvement in technology would change Colorado and the Pike's Peak Region forever. What had been spawned by gold would be sustained by iron.

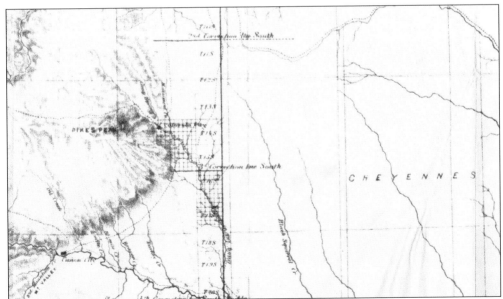

Although there is little on this 1863 map that would suggest the settlement of the Pike's Peak Region, it was at this time that the area was starting to develop. Population centers such as Colorado City are noted. Also of interest is the land to the east, designated for the Cheyenne Indians.

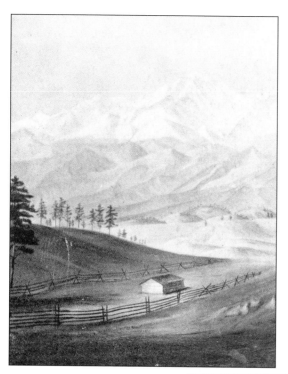

Noted early Denver photographer William G. Chamberlain documented this Colorado Springs artist's drawing, a rare example of the pre-railroad 1860s. A cabin and pasture are nestled in the rolling hills near the confluence of Monument and Fountain Creeks. The cabin was probably the homestead of John Potter, who established a ranch east of Colorado City near the banks of Monument Creek, and was instrumental in helping General Palmer acquire land for the Fountain Colony. One of the Pike's Peak Region's charter citizens, Potter became the first postmaster of Colorado Springs in 1872. (Photo by William G. Chamberlain.)

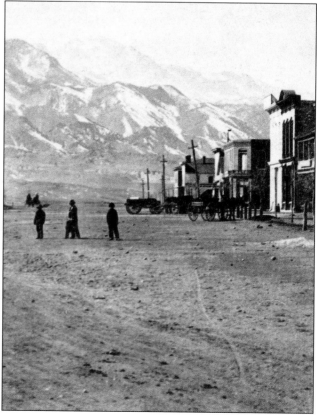

Early Colorado Springs pedestrians walk south across Pike's Peak Avenue in this photo taken in the mid-1870s. This photo shows a portion of the quickly developing business district. Despite the nation's economic troubles, the 1870s proved to be a period of moderate growth for the Pike's Peak Region. (Photo by B.H. Gurnsey.)

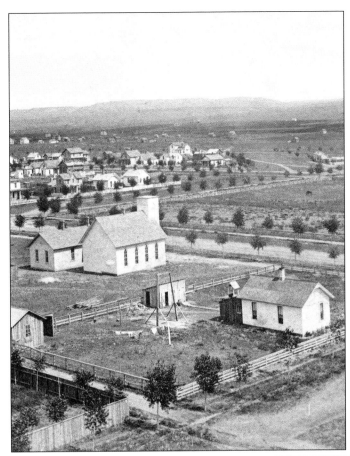

Part of a series of Gurnsey photographs taken from the clock tower of the school, this view looks to the northeast. In the lower right corner of the photo is Bijou Street. The white building in the middle of the photograph is the Cumberland Church. The hills in the distance are the heights around Templeton Gap and Austin Bluffs. (Photo by B.H.Gurnsey.)

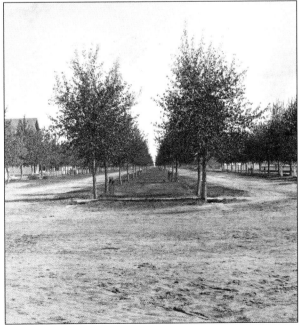

This view shows Nevada Avenue looking north. The trees planted by E.S Nettleton in 1872 were already affording shade to some Colorado Springs residents when this photo was taken around 1880. Nettleton, the chief engineer of the Colorado Springs Company, shared Palmer's dream of spacious and comfortable avenues and incorporated these ideas into the residential areas that he built on the north side of town. (Photo by L.K. Oldroyd.)

11

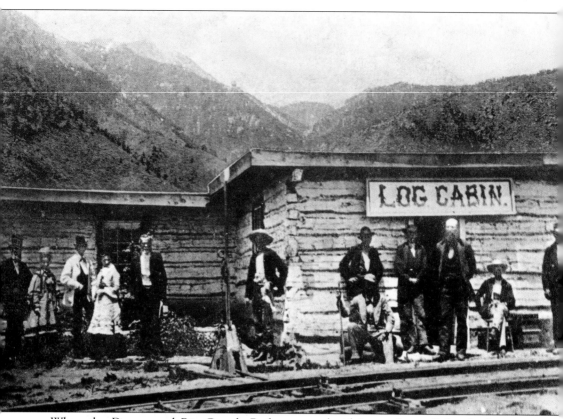

When the Denver and Rio Grande Railway completed its tracks to Colorado Springs on October 21, 1871, the aptly named "Log Cabin" became the region's first railroad depot. The building was an expanded version of a modest shelter built in 1870 by ex-governor A.C. Hunt and several associates. Colorado Springs served as the southern terminus of the D&RG until March 25th, 1872, when General Palmer's track crews began laying rail toward Pueblo. It is interesting to note that the photographer superimposed a mountain backdrop, giving the impression that the depot was much closer to foothills than it actually was. Perhaps it was thought that the combination of rugged architecture and mountain scenery would sell more "stereoviews." (Photo by B.H. Gurnsey.)

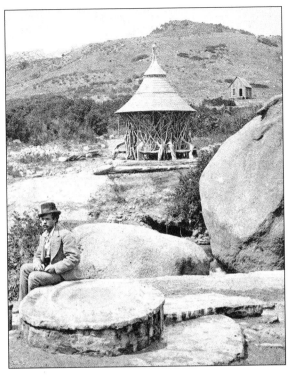

While the Utes and other Native-American tribes had enjoyed the beauty and spirituality of the Manitou springs for centuries, such benefits were still a novelty to the Victorian visitors from the East. Each spring varied in chemical and mineral content, as did the respective medicinal benefit. This 1875 Gurnsey view shows two of Manitou's most popular springs, the Navajo and the Manitou Soda Spring. While these springs would later be housed in more ornate structures, the Spartan surroundings probably made a greater impression on the early health-conscious tourist. (Photo by B.H. Gurnsey.)

Completed in 1874, the Cliff House was one of the most popular hotels in Manitou. Edward E. Nichols purchased the hotel from the Keener Family in 1880. Taken a few years after the hotel changed hands, this photo shows the newly completed annex to the right of the main building. In the foreground are two of Manitou's famous springs. The small gazebo in the middle of the photo covers the Manitou Soda Spring while the more substantial pavilion on the left houses the Cheyenne Spring. (Photo by B.H. Gurnsey.)

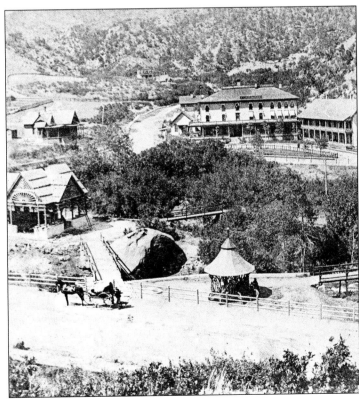

Prior to the completion of the D&RG's Manitou Branch in 1880, many travelers to the new resort community arrived in stages like this one. Manitou was served by local and long-distance stage companies. This rough and dusty mode of transportation would soon fall by the wayside. By 1880, the people of Manitou had their own rail connection, and anyone wishing to travel to Leadville by rail could do so on the D&RG's new main line via the Royal Gorge.

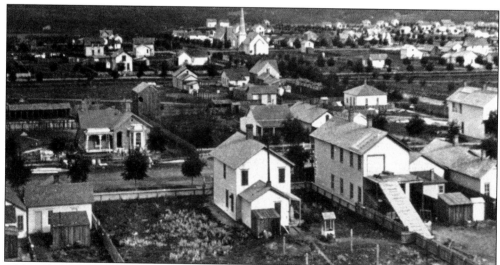

Although wells and outhouses were still the norm when this 1870s photograph was taken, it demonstrates how quickly Colorado Springs changed from a prairie settlement into a town. This photo was taken from the tower of the first formal school in Colorado Springs. Located on the west end of the Colorado Springs, the school proved to be a longer walk for some children, but it did afford photographer B.H. Gurnsey a panoramic view of the southeastern portion of town. (Photo by B.H. Gurnsey.)

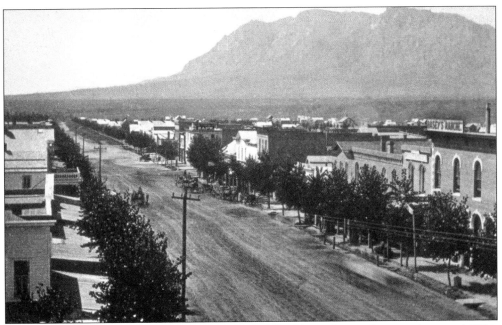

The absence of horse-car tracks places the date of this Tejon Street photograph around 1884. The view looks southward along what was then part of the major business district in Colorado Springs. In the distance is the outline of Cheyenne Mountain.

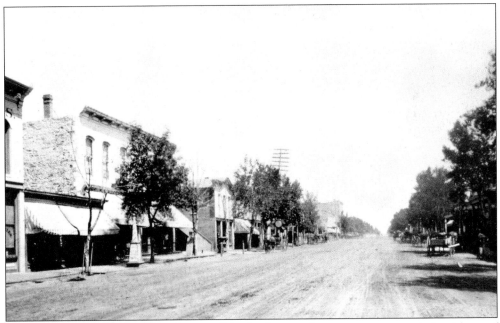

In the mid-1880s, North Tejon Street still had a few wooden structures to remind residents of its humble beginnings. However, more stone and brick buildings were being built, giving the business district a greater sense of permanence. In just a few short years, the tracks of the Colorado Springs and Manitou Street Railway would carry shoppers and sightseers along Tejon Street and other busy thoroughfares.

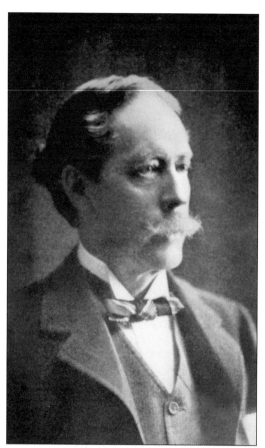

Perhaps no other man made a greater impact on the early history of Colorado Springs than William Jackson Palmer. President of the region's first railroad, the Denver and Rio Grande, Palmer's narrow-gauge line connected the Pike's Peak Region with the outside world. Palmer was also the guiding force of the Colorado Springs Company, a land development corporation that fostered the colonization of Colorado Springs and played a great role in regional growth and the town's success throughout the 19th century.

This photo, taken about 1874, shows General Palmer's first home at Glen Eyrie. Of all the land acquisitions made by Palmer for the Colorado Springs Company, he saved the most beautiful 225 acres for himself. Although this photo depicts the first Glen Eyrie, Palmer later transformed his mansion into the palatial residence that survives to this day. Palmer's home was undoubtedly the finest estate in the Pike's Peak Region and a fitting tribute to such a benevolent visionary. (Photo by W.G. Chamberlain.)

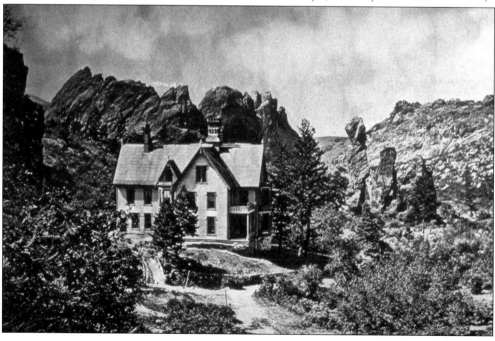

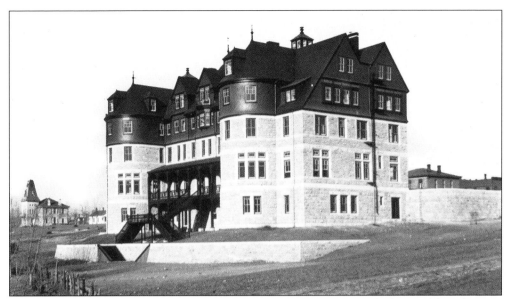

Through the 1880s and 1890s, the Antlers Hotel was synonymous with the wealth and development of Colorado Springs and the Pike's Peak Region. This photo shows the Antlers about 1885, a few years after its construction. The popularity of the hotel was due in part to its close proximity to the D&RG depot. In the distance is the public school with its mansard roof. The hotel was not only a favorite among Colorado tourists, but also a permanent residence for some of the region's wealthiest bachelors. (Photo by William H. Jackson.)

Advertisements like this that appeared in railroad timetables and magazines throughout the country made the Antlers Hotel nationally known. In 1881, some of the area's leading businessmen, including General Palmer, realized the need for Colorado Springs to have a premier hotel. Out of this consensus came the incorporation of the Antlers Hotel on May 16, 1881. In June 1883, the hotel was opened for business, amid claims that it was the finest establishment of its kind west of the Mississippi.

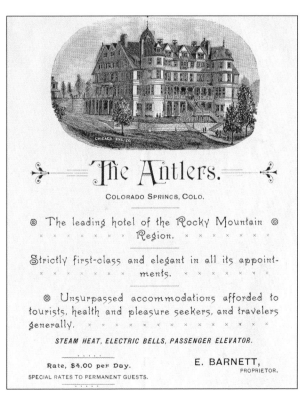

The Antlers.

COLORADO SPRINGS, COLO.

◎ The leading hotel of the Rocky Mountain ◎ Region.

Strictly first-class and elegant in all its appointments.

◎ Unsurpassed accommodations afforded to tourists, health and pleasure seekers, and travelers generally.

STEAM HEAT, ELECTRIC BELLS, PASSENGER ELEVATOR.

Rate, $4.00 per Day.

E. BARNETT, PROPRIETOR.

SPECIAL RATES TO PERMANENT GUESTS.

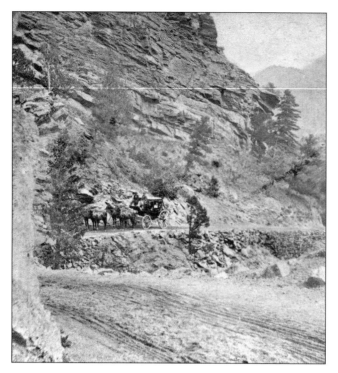

For many of Colorado's territorial fortune seekers, the gateway from the plains of Colorado to the rich gold fields of South Park was through Ute Pass. By the 1860s, settlers had transformed the old Native-American trail into a wagon road. Over this road, hundreds of tons of supplies were hauled. As this photo demonstrates, a good many passengers were transported as well. Picking up fresh horses at stations along the way, several freight and stage companies made a booming business bringing supplies to the mining camps. (Photos by W.G. Chamberlain.)

Throughout the 1870s, the town of Manitou continued to grow, and so did its reputation as a health resort. Some of the wealthier visitors stayed in Manitou for the entire season. The area afforded a great deal for local guests, with walks to nearby Rainbow Falls and Garden of the Gods and, for the more adventurous, a hike up Pike's Peak. This photograph shows the Cliff House and its annex. Pathways and bridges connected many of the springs and hotels. (Photos by William H. Jackson.)

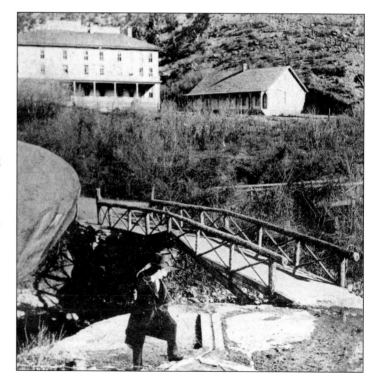

Two
DENVER & RIO GRANDE

The Denver & Rio Grande was the Pike's Peak Region's first railroad and arguably remains Colorado's most popular. The D&RG built its narrow-gauge railroad to Colorado Springs in 1871. General Palmer's relationship with both the D&RG and Colorado Springs ensured the town of a prominent role in the railroad's early operations. As the town began to grow, so did the railroad's presence. In 1880, a five-mile branch was built west from Colorado Springs to the budding resort community of Manitou. The D&RG also added a third rail to its mainline, which now carried narrow and standard-gauge equipment. Over time, the ability of Colorado Springs to generate freight for the D&RG would diminish, but its attraction as a tourist destination provided a great amount of passenger revenue. For many years this relationship would prove very lucrative for both the railroad and the area.

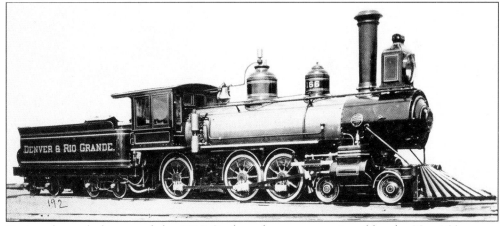

During the early history of the D&RG, three-foot-gauge engines like the No. 166 were a common sight in and around Colorado Springs. This engine was part of an order of 12 T-12 Class narrow-gauge engines built by Baldwin between 1883 and 1884. These engines were called "ten-wheelers" after their 4-6-0 wheel arrangements. After a third rail was added to the D&RG tracks, the road started to acquire more standard-gauge engines. As these new locomotives began to arrive, narrow-gauge engines like the No. 166 were often relegated to narrow-gauge service.

DENVER AND RIO GRANDE RAILWAY.

Daily Report of Tickets, *Issued for the respective Trains, at* Colorado Springs Station, *for the* 29th *day of* August 1872

DESTINATION.	Closing No. for the Day. No. 1. Closing.	No. Tickets Sold.	No. 2. Closing.	Closing No. for the Day.	No. Tickets Sold.	Rate. Dolls. Cts.	Amount. Dolls. Cts.
DENVER,	2269			2290	11	5 75	63 25 ✓
LITTLETON,	75			75	11		
ASCEQUIA,	1			1			
PLUM,	4			4			
CITADEL,	11			11			
DOUGLAS,	2			2			
LARKSPUR,	22			22			
PINELAND,	1			1			
DIVIDE,	6			6			
HENRY'S,	7			7			
BORST'S,	13			13			
SOUTHWATER,	43			43			
MONUMENT,	42			43	1		65 ✓
COLORADO SPRINGS,							
Widefield	2			2			
Fountain	21			21			
L Buttes	91			91			
Wigwam	1			1			
Pinon	11			11			
PUEBLO,	160			165	5	3 40	17 00 ✓ ✓
							80 90

Coupons to Leavenworth
Form 1006 Nos 1 + 2 $47 35 94 50
TRINIDAD,							178 40
CIMARRON,							
FT. UNION,							
LAS VEGAS,							
SANTA FE,							

I hereby certify the above to be correct.

J.M. Ellison **AGENT.**

NOTE.—This Report must be forwarded to the General Ticket Office by the first train every morning, and must include all the sales of the previous day.

Station agents in the 1870s played an important role in the business of railroading. A fine example of this was the D&RG's Colorado Springs agent J.M Ellison. Agents often performed multiple jobs, including telegraph operator, inbound and outbound freight processing, the accommodation of passenger traffic, and, as this form suggests, accountant. The form in this photo is a daily passenger balance sheet for the Colorado Springs depot from August 29, 1872. It is interesting that the tracks to Pueblo had only recently been completed, as evidenced by the inclusion of handwritten stations south of Colorado Springs. (Courtesy of P.R."Bob" Griswold.)

By the 1880s, the town of Colorado Springs was not only a source of great outbound passenger traffic, but also a popular destination. For business and pleasure, travelers visited Colorado Springs from around the state and around the country. This ticket was issued on May 24, 1888 between Sapinero, Colorado and Colorado Springs. These destinations are indicative of the combined standard- and narrow-gauge travel that would have been required between many of the D&RG's stations at that time.

DENVER & RIO GRANDE RAILROAD.

BLANK LOCAL TICKET STUB.-Not Good for Passage

SAPINERO

To *Colo Spgs*

Acc't of

Issued *5/24* and Expires

OFFICE **1286** Rate *11*

1-7-88

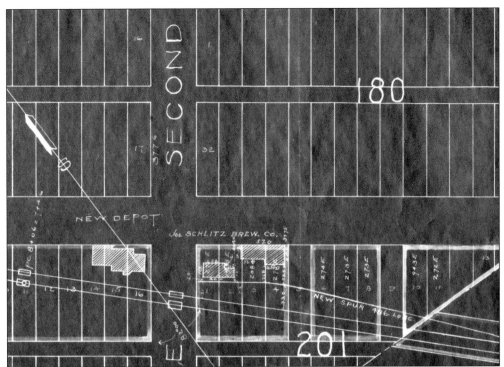

Built in 1880, the narrow-gauge Manitou Branch linked the D&RG's mainline in Colorado Springs with the growing resort town of Manitou. Colorado City became a beneficiary of this extension, and rail service helped the town to prosper. This 1890s station map shows the location of the D&RG's depot on Second Street across from the Schlitz Beer Distributor. Although railroad regulations forbid the consumption of alcohol on duty, stopping next to a brewery must have been a strong temptation for thirsty train crews.

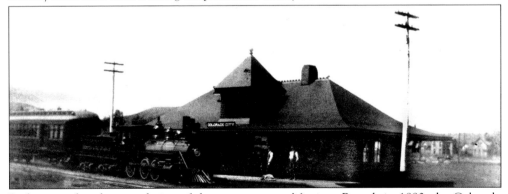

Built soon after the completion of the narrow-gauge Manitou Branch in 1880, the Colorado City depot of D&RG was initially a place of great activity and was the town's only depot until the construction of the Colorado Midland Railway in 1886. This scene, captured on June 6, 1891, shows eastbound "ten-wheeler" No. 525 and a combine poised to receive passengers and the daily mail. Also in evidence is the D&RG's "third rail" added in 1888 to accommodate standard-gauge equipment. In the background on the right is a portion of the Colorado City business district, and on the left is the distant Ute Pass. Barely a year old when this photo was taken, Engine No. 525 served the Manitou line and later in the La Veta area. (Photo by Horace Poley.)

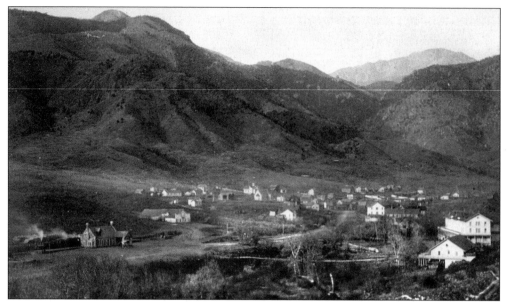

This view of Manitou looks west and was taken soon after the D&RG completed the Manitou Branch in 1880. Yet to be built are the D&RG freight and engine house. Also absent from the scene is the depot's well-manicured lawn and flowerbeds. To the right of the photograph is the Manitou House and further in the distance, The Mansions. The grade of the Colorado Midland Railway would later be built on the high ground in back of the depot. The Colorado Springs Local is heading eastbound and ready to leave Manitou. (Photo by William H. Jackson.)

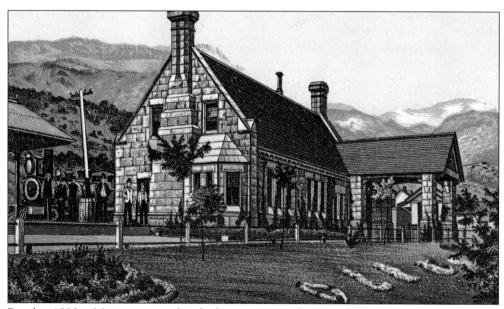

By the 1880s, Manitou was already known as a playground for the wealthy, and the management of the Denver and Rio Grande kept this in mind when designing its depot. The engraving of the handsome stone station was done about 1885. The first floor of the depot contained a ticket office and waiting room, while the second floor housed the station agent and his family.

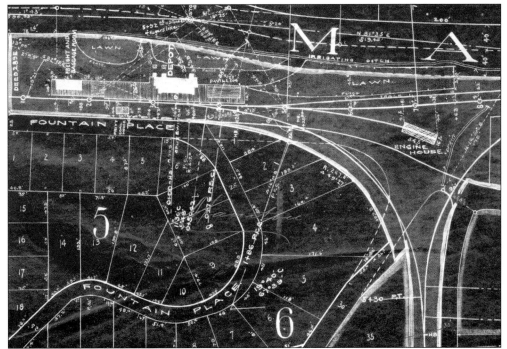

This blueprint was done in the early 1890s and shows in great detail the D&RG facilities in Manitou. To the extreme left of the image is the freight house, followed by the coal shed on the south side of the tracks, the stone depot, and the passenger platform. To the right in the middle of the wye, a single-stall engine house was built. The tail of the wye extended to the south and went under the right-of-way of the Colorado Midland.

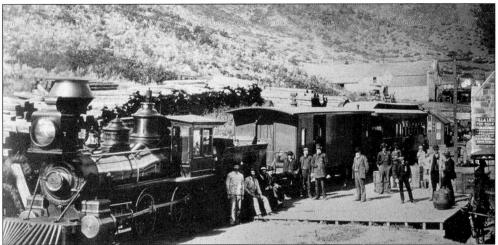

Built in 1878, No. 26 was dubbed the "Rio Bravo" and part of the D&RG's 38 Class 4-4-0s. The five short miles of the Manitou Branch were ideal for some of the D&RG's smaller narrow-gauge equipment. Although woefully underpowered for mainline service, the relatively flat grade and small volumes of passenger and freight traffic bought a second life for engines like this. Despite its supporting role, however, the No. 26 was still well-maintained. In this photo, crewmembers proudly pose next to the engine's gleaming boiler. (Photo by William H. Jackson.)

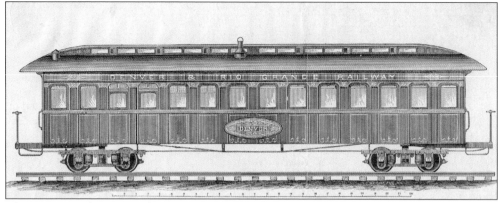

The Denver and Rio Grande's first formal passenger coach was named the "Denver." Built by Jackson and Sharp Works in Wilmington, Delaware, General Palmer's three-foot railroad was a bit of a novelty to the larger-gauge railroads in the East. The "Denver" and its sister coach, "El Paso," were part of the first excursion train to Colorado Springs on October 26, 1871.

In an effort to draw attention to its route and the geographical area it served, maps such as this one were a prominent part of D&RG literature. Published in 1883 at the end of General Palmer's reign over the D&RG, this map illustrates the growth experienced by the D&RG in the early 1880s.

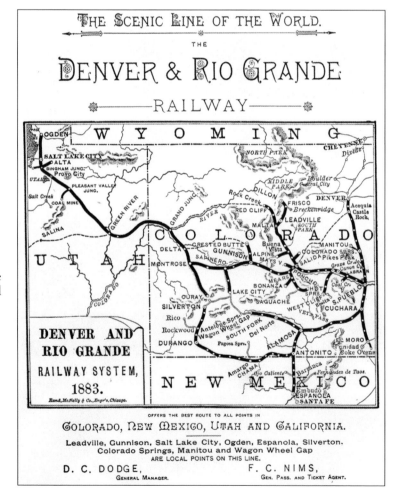

One of the most prized possessions in the author's image archive is this carde-de-visite of James De Remer. The image was taken by an unknown Denver photographer in 1875 about the time DeRemer began working for the Denver and Rio Grande. When the D&RG came out of the economic doldrums prompted by the "Crash of '73," men such as De Remer were instrumental in helping to bring stability to the road.

William Wagner was one of General Palmer's most trusted associates. Their relationship went back to the Civil War when both served with the 15th Pennsylvania Cavalry. Even before he came to Colorado, Wagner already had a good understanding of railroads from his experiences in the East. During the closing days of the Civil War, troops under Major Wagner's command destroyed portions of the Virginia and Tennessee Railroad, which helped prevent the joining of Confederate forces under Lee and Johnston and helped seal the fate of the Army of Northern Virginia. Six years later, Wagner proved he could build railroads as well as destroy them. Wagner became the secretary of the Union Contract Company, the construction company set up by Palmer to build the Denver and Rio Grande.

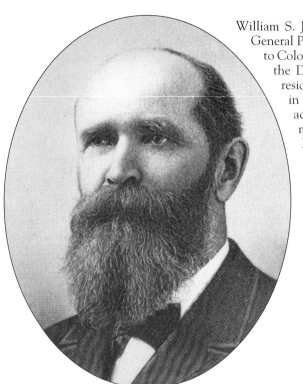

William S. Jackson epitomized the type of men General Palmer would bring to his railroad and to Colorado Springs. Jackson was treasurer of the D&RG from 1871 to 1876, and as a resident of Colorado Springs, was active in local banking and real estate. By all accounts a family man, Jackson married the famous author and Indian-rights advocate Helen Hunt in 1875.

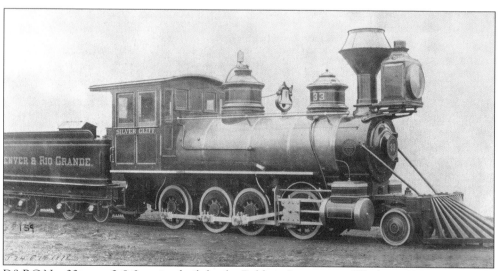

D&RG No. 33 was a 2-8-0 engine built by the Baldwin Locomotive Works in 1878. Commonly referred to as "Consolidations," the early D&RG used 2-8-0s in both freight and passenger service. Engine No. 33 was named the "Silver Cliff" after a mining town near Rosita, Colorado, which boomed about the same time the locomotive was delivered.

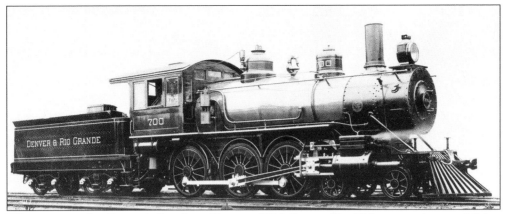

When it arrived at Denver's Burnham Shops in 1896, Engine No. 700 was a welcome addition to the D&RG's aging fleet of passenger locomotives. Built by the Baldwin Locomotive Works, this engine sported six powerful 63-inch drivers and 200 pounds of boiler pressure. No. 700 was part of an order of 12 similar standard-gauge engines and served the railroad until 1924.

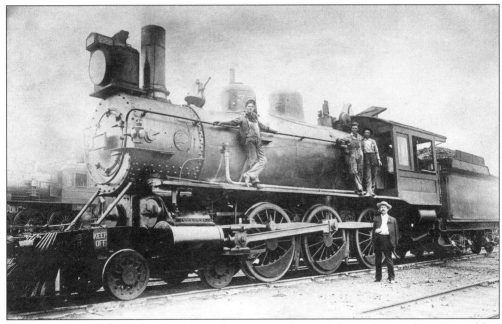

Shown in front of the Colorado Springs depot soon after its delivery, Engine No. 728 and her proud crew pose for a photograph. In 1899, the Denver and Rio Grande placed an order for 20 4-6-0 engines from the Brooks Locomotive Works in Dunkirk, New York. This and subsequent orders were an attempt to remedy the shortage of larger passenger engines. These engines, numbered from 720 to 739, were known as the D&RG's T-28 Class. Interesting in this scene is the crewman on the ground with his arm in a sling—perhaps a conductor who failed to put "safety first."

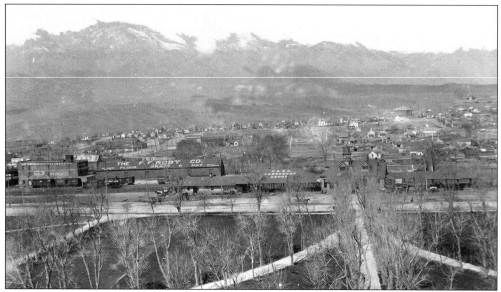

This dramatic photo, taken from one of the rooms in the Antlers Hotel, looks west across Antlers Park toward the Denver & Rio Grande depot. As the town of Colorado Springs grew, the D&RG passenger facilities were expanded to accommodate the increase in population. The original stone depot is flanked by open-air pavilions to the north and south. The building to the left of the station is the baggage depot. In the background, an engine switches cars near the Roby Warehouse.

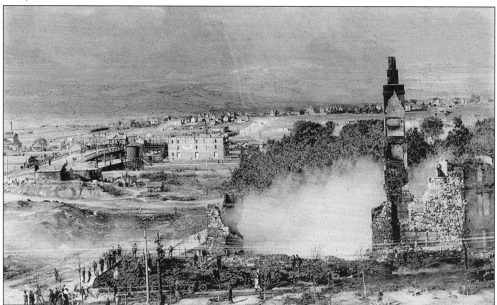

The 1898 fire that claimed the Antlers Hotel came close to destroying the D&RG depot. Prevailing winds out of the southwest enabled the depot to escape the flames. Photographed while the ruins were still smoking, this scene shows the curious crowd who gathered to pay last respects to one of the towns greatest landmarks. In the distance is a view of the "South Tank" as well as the Huerfano Street Viaduct. Railroads helped make the Antlers a success. In an ironic twist of fate, it was proximity to the tracks that helped destroy it.

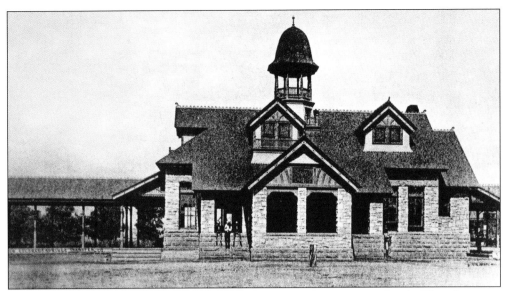

Shown here are several D&RG employees as they enjoy their morning break. This photo was taken prior to the addition of the north wing and the expansion of the waiting room. This serene setting would not last long. The next train would bring throngs of passengers, freight, and baggage. Such business and congestion created a need for signs, such as the one at the base of the south platform reserving space for the Colorado Spring Transfer Company.

From the time of its completion, the D&RG's Manitou Branch began to pay for itself. The hotels and springs of Manitou were growing in popularity, as were the local D&RG passenger runs between Colorado Springs and Manitou. By 1883, it was common to see advertisements, such as this one, in D&RG literature. The passenger department of the D&RG also distributed pamphlets about Manitou.

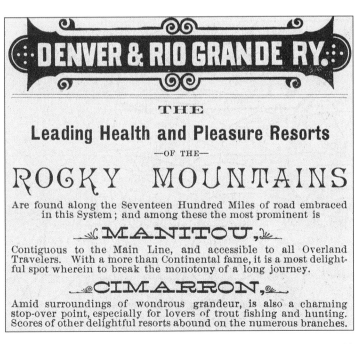

DENVER & RIO GRANDE RY.

THE

Leading Health and Pleasure Resorts

—OF THE—

ROCKY MOUNTAINS

Are found along the Seventeen Hundred Miles of road embraced in this System; and among these the most prominent is

MANITOU,

Contiguous to the Main Line, and accessible to all Overland Travelers. With a more than Continental fame, it is a most delightful spot wherein to break the monotony of a long journey.

CIMARRON,

Amid surroundings of wondrous grandeur, is also a charming stop-over point, especially for lovers of trout fishing and hunting. Scores of other delightful resorts abound on the numerous branches.

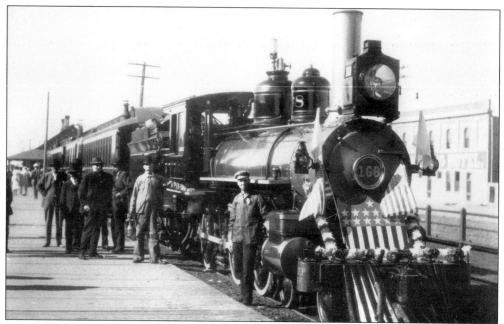

While other railroads sold off their surplus engines as they became outdated, many of the narrow-gauge engines on the D&RG had exceptionally long lives. Narrow-gauge engines on the Rio Grande found many uses. For these areas, passenger service fell to engines such as the No. 168. Still on "active duty" and looking well after 25 years of service, the No. 168 pauses in Montrose pulling the "Presidential Special" and President William Howard Taft. This engine would have the good fortune to be spared from the scrapper's torch and was later placed on display in Colorado Springs.

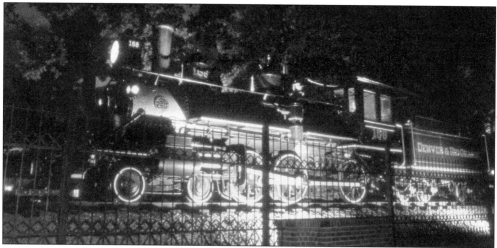

Although time and technology have changed transportation in the Pike's Peak Region, there are still reminders that capture the nostalgia of Colorado narrow-gauge railroading. Such a reminder is D&RG Engine No. 168. Built by the Baldwin Locomotive Works in 1883, this engine had a long life on the narrow-gauge, serving more than 50 years before finally being taken out of service. In 1938, the railroad presented the little 4-6-0 locomotive to the City of Colorado Springs. Engine No. 168 still survives and is on display in Antlers Park, across the street from the old depot she once proudly served.

Three

DENVER & NEW ORLEANS

Of all the railroads that served early Colorado Springs, the history of the Denver & New Orleans is perhaps the most poignant. The D&NO was the dream of ex-Colorado governor and capitalist John Evans. Evans envisioned a railroad that would link Colorado with the ports of coastal Texas. While the ambitions of Evans were substantial, the coffers of the D&NO were not. The railroad was built on the hopes that the business of Colorado commerce was a level playing field, when in fact it was anything but. Connected to terminal points where already entrenched competitors refused to cooperate, the D&NO starved for revenue. A financially induced reorganization saw the D&NO reemerge as the Denver, Texas & Gulf. By 1890, the Union Pacific Railroad gained control over the line and incorporated the DT&G into the new Union Pacific, Denver & Gulf.

DENVER AND NEW ORLEANS RAILROAD
THE BROAD GUAGE ROUTE TO THE SOUTH.

TWO FAST EXPRESS TRAINS DAILY.
THE ONLY LINE

RUNNING ITS OWN TRAINS OVER BROAD GAUGE TRACKS
BETWEEN

DENVER and PUEBLO

OWNED AND OPERATED BY COLORADO CAPITALISTS

Elegant Day Coaches and Pullman Parlor Cars on all Trains.

Rates as Low as the Lowest.

C. W. FISHER,
General Manager.

W. H. PRICE,
Traffic Manager.

Almost from the start, the Denver & New Orleans found itself hurting for through-passengers. Those that did patronize the line usually did so locally, traveling from Colorado Springs or Denver to the more agrarian-based communities nearby. In an effort to draw customers away from its competitors, the D&NO turned to advertising. In the hopes of attracting the more lucrative Denver-to-Pueblo passenger line, business ads such as this one began to appear in local newspapers and railroad timetables. This 1882 ad touts the D&NO's "broad gauge" and the comfort of Pullman travel, as well as taking a jab at the Santa Fe in referencing home-road operations.

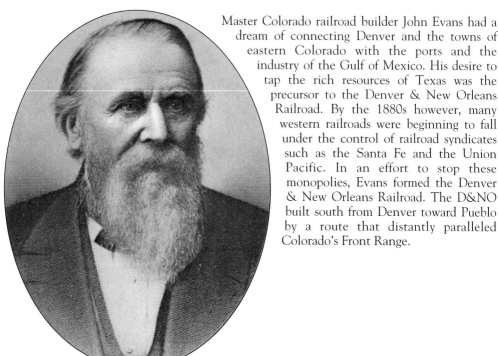

Master Colorado railroad builder John Evans had a dream of connecting Denver and the towns of eastern Colorado with the ports and the industry of the Gulf of Mexico. His desire to tap the rich resources of Texas was the precursor to the Denver & New Orleans Railroad. By the 1880s however, many western railroads were beginning to fall under the control of railroad syndicates such as the Santa Fe and the Union Pacific. In an effort to stop these monopolies, Evans formed the Denver & New Orleans Railroad. The D&NO built south from Denver toward Pueblo by a route that distantly paralleled Colorado's Front Range.

One of the chief allies of John Evans was Grenville M. Dodge, the driving force of the Texas-based Fort Worth & Denver City Railway. As Evans built south from Denver, Dodge was extending his road north. He is shown in this Civil War photo in the uniform of a Union major general. Whether fighting Confederates, Native Americans, or other railroads, Dodge was a force to be reckoned with. After the war, Dodge applied his talents as chief engineer to the Union Pacific Railway. Although constantly short of funds, the D&NO might have fallen easy prey to the interests of the Santa Fe, had it not been for the solidarity of the Evans-Dodge partnership.

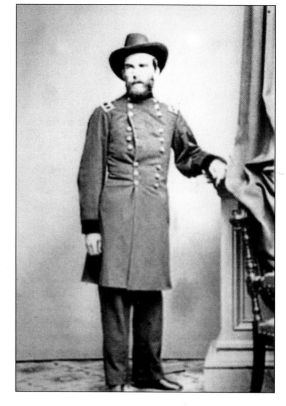

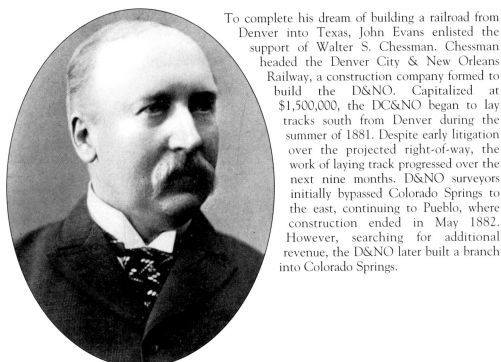

To complete his dream of building a railroad from Denver into Texas, John Evans enlisted the support of Walter S. Chessman. Chessman headed the Denver City & New Orleans Railway, a construction company formed to build the D&NO. Capitalized at $1,500,000, the DC&NO began to lay tracks south from Denver during the summer of 1881. Despite early litigation over the projected right-of-way, the work of laying track progressed over the next nine months. D&NO surveyors initially bypassed Colorado Springs to the east, continuing to Pueblo, where construction ended in May 1882. However, searching for additional revenue, the D&NO later built a branch into Colorado Springs.

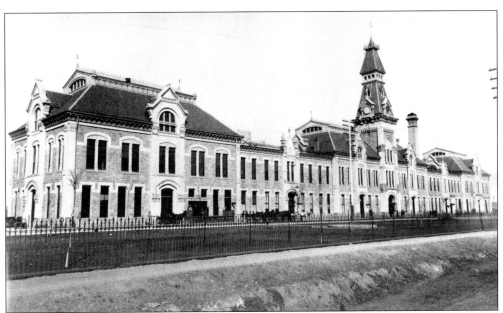

Completed in 1881, Denver's Union Depot was a showpiece of modern architecture, and a major departure from the utilitarian appearance of some of the railroad's lesser facilities. D&NO's use of this depot at its northern terminus was due in part to the efforts of Walter Chessman, who had interests in both entities. In later years, Train No. 1, The Pueblo & Colorado Springs Express, left Union Depot each morning at 8 a.m. and returned each evening at 7 p.m. (Photo by William H. Jackson.)

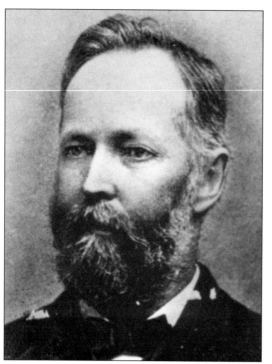

Matt France first came to the Pike's Peak Region as a pioneer in 1860. As one of the few telegraphers living in the new territory, France temporarily moved to the Clear Creek Mining District and turned his skills into a lucrative commodity. His mining experiences would serve him well and would be the basis for his relationship with the Denver & New Orleans Railroad. France, along with other local businessmen, worked in conjunction with the D&NO to transport coal from the mines along Jimmy Camp Creek to Colorado Springs and Denver. Although the medium of the mineral would change, France continued his association with mining into the 1890s and became a corporate officer in several gold mines in the Cripple Creek District.

The Denver and New Orleans R.R.
Profile
of
Constructed Coal Line.

THE DENVER AND NEW ORLEANS R.R.
ACCOMPANYING REPORT OF
THE CHIEF ENGINEER.
Made _March 25th_ A.D. 1882.

This 1882 track profile shows a portion of D&NO's new Franceville coal mine branch. With the appearance of the D&NO, Matt France saw a great opportunity. Wagons, which had once brought coal from Corral Bluffs and other mines east of Colorado Springs, could now be replaced by the more efficient gondolas of the D&NO. Desperate for revenue, the management of the D&NO worked with France and other local businessmen. This collaboration was soon evident on the D&NO's timetable, as the stations of Franceville and Franceville Junction were named in his honor.

For four years, the D&NO lingered on the plains, isolated by geography and starving for business on both ends. Seeking an alliance that would heal the financial hemorrhage, Evans approached the Missouri Pacific in 1885. After a quick dismissal from the shrewd Jay Gould, Evans reorganized the D&NO as the Denver Texas and Gulf Railway. In ads printed soon after the reorganization, agent Chauncey Curtiss introduced the DT&G to the people of Colorado Springs. At this time, George Pullman's palace cars were all the rage, and if that was not enough incentive to ride the road less traveled, Superintendent Grover promised patrons they would travel quickly, comfortably, and safely. What more could a passenger ask for?

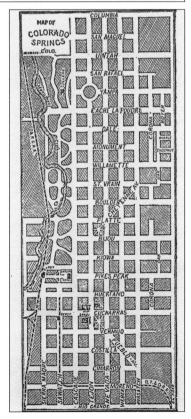

Upon its arrival into Colorado Springs, the Denver & New Orleans Railroad built a small depot at 103 Cucharras Street. Located amid lumber, coal yards and the homes of the "working class," the original wooden passenger station sat across the street from the D&NO's freight depot. This rare 1886 map shows the tracks of the D&NO's successor, the Denver, Texas & Gulf, and the area surrounding the station. What the first depot lacked in aesthetics, it made up for in convenience. The Spaulding and Alamo Hotels were only a block to the east, and the Antlers was two blocks to the north.

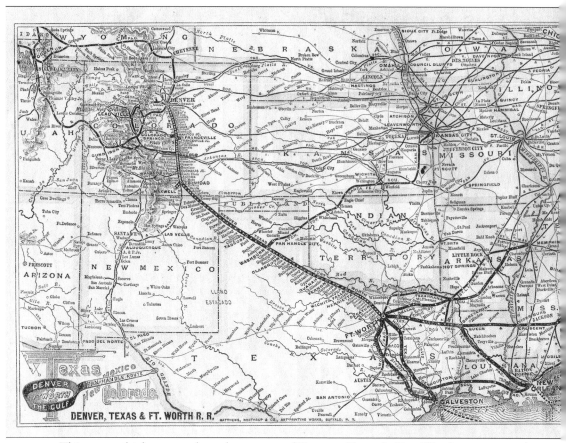

This map, which appeared on the reverse of Denver, Texas & Fort Worth stationary, shows what Evans and Dodge had strived for: a completed railroad from Denver to Fort Worth. Known as the Panhandle Route for its projection across Northern Texas, the DT&FW was Dodge's answer to a Santa Fe offer to buy out the DT&G. In 1887, the General, armed with renewed enthusiasm and some badly needed capital, began to spur his construction crews toward Colorado. Thwarted by its efforts to purchase the DT&G, the Santa Fe decided to build its own connection between Pueblo and Denver.

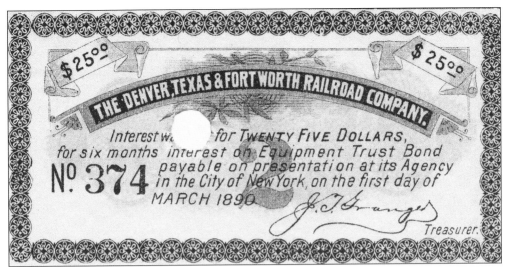

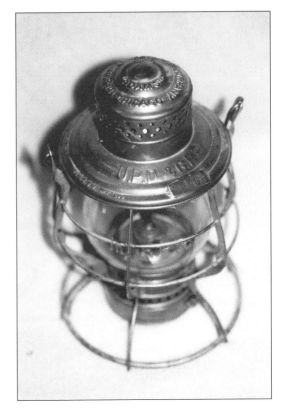

Building a railroad took more than just rails and equipment; it took money—and plenty of it. Land grants, natural resources, and large population centers were all considerations in western railroad building, but capital was the deciding factor. Stocks and bonds would serve as the tools to generate this capital. This DT&FW bond coupon was one of thousands purchased by eastern investors who could redeem them after a stipulated date. The bond has a facsimile signature of the railroad's treasurer, John T. Granger.

This well-preserved brakeman's lantern dates from 1892 and was manufactured by the Adams & Westlake Company of Chicago. The lantern's lid is marked "UPD&G," for Union Pacific, Denver & Gulf, while the glass globe is embossed "Union Pacific," denoting the ownership of both the parent railroad and the subsidiary. Lanterns like this were used by railroad employees for both signaling and illumination.

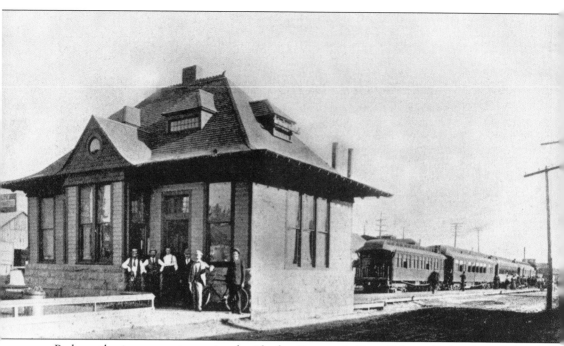

Perhaps the image most associated with the Denver & New Orleans Railroad in Colorado Springs, the depot in this photo was actually constructed after the demise of the D&NO by the Union Pacific Denver & Gulf. The D&NO and later the DT&G used a depot on the southwest corner of Cucharras and Sahwatch In 1890, after the Union Pacific gained control over the Evans-Dodge conglomerate, this station was built a block to the north. The new depot was closer to the Antlers Hotel and the Denver & Rio Grande. This photo shows the north side of the station. In front of where these men are posed was a small outdoor waiting area. A platform extended south from the depot along both sides of the track. Across the street just north of the Dilts Lumber Yard was the "UPD&G Lunchroom" and the modest but comfortable Home Hotel. (Photo by George R. Buckman.)

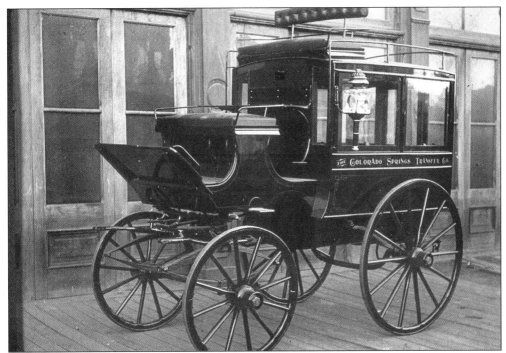

Although known for its express service, the Colorado Springs Transfer Company also moved people. Taken at the Antlers Hotel prior to 1898, the photo reveals that this handsome coach could carry six people along with their baggage and a driver. With glass panels inserted for winter operations, coaches like these ferried passengers between the depots of the D&RG, Santa Fe, and the UPD&G.

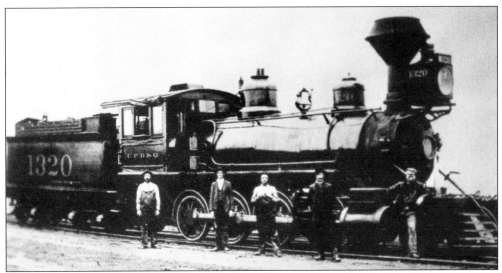

Built by the Baldwin Locomotive Works in 1889, UPD&G No. 1320 was typical of the 2-8-0 engines in the Gulf Road's stable. Although the photo was taken in Denver, No. 1320 undoubtedly saw some service in Colorado Springs. This engine later became Colorado & Southern Railway No. 410.

While in Colorado

You will of course wish to see the most attractive scenery and visit the principal resorts of the State. Nearly all of Colorado's beauty spots are along the lines of

The Gulf Road,
(U. P. D. & G. R'Y.)

or the South Park Line,
(D. L. & G. R'Y.)

and these lines offer during the summer months very fascinating excursions into the mountains at most reasonable rates.

Of course there are so many of these tempting trips that we could not even briefly mention them in this space. We will very cheerfully give you detailed information on the subject upon application.

Have you received a copy of our pretty book, "A Day in the Canons of the Rockies?" Enclose us a two cent stamp and we'll mail you a copy, or you may have it absolutely free by asking the Gulf Road Agent.

T. E. Fisher,
Assistant General Passenger Agent,
DENVER, COLORADO.

This advertising handbill from about 1897 emphasizes two of the Union Pacific's major Colorado subsidiaries. Known as the "South Park Line," the Denver, Leadville & Gunnison Railway basically consisted of the old Denver, South Park & Pacific's route from Denver west to Gunnison. The UPD&G was the amalgamation of several different Union Pacific entities, and gave "The Gulf Road" the distinction of having both narrow- and standard-gauge operations. In 1898, after each road had fallen into receivership, the DL&G and UPD&G were combined to form the Colorado and Southern Railway.

Adorned with a non-typical smokestack, this Union Pacific 4-4-0 pauses in Elbert, Colorado on its return from a tour over the line. This 1890 photograph finds a train filled with railroad officials and local dignitaries who were invited to tour the former route of Denver, Texas & Gulf. On a full day's outing, the train probably journeyed to Pueblo in the morning and lunched in Colorado Springs on the return trip.

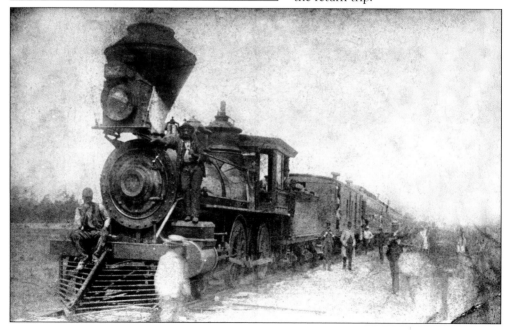

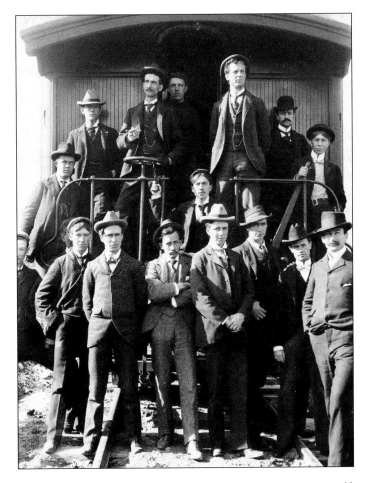

5299 U. P. D. & G. Manitou Jt. Colo.

Without proper security, the contents of freight cars could easily be stolen. Seals like this one were usually used to secure the doors of boxcars. The seal was attached to a tin strap, which had the name of the railroad, shipment number, and the station of origin either stenciled or embossed on the metal. This seal was for cars loaded at Manitou Junction, where the branch to Colorado Springs connected to the main line of the UPD&G.

The Colorado Springs branch of the D&NO and later the UPD&G entered the town from the east. On its approach, the right-of-way came close to Prospect Lake. Although a trolley line served this area, occasionally so did the UPD&G. This 1897 photo shows members of the accounting and mechanical department headed for a summer outing at Prospect Lake. These men were part of a larger charter group who had left Denver for Colorado Springs. John C. Nelson, second to the right on the bottom row, had a long career with the Union Pacific and later, the Colorado & Southern Railway.

41

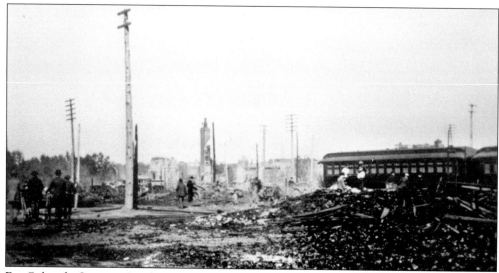

For Colorado Springs, October 1, 1898, was indeed a "hot time in the old town." A fire that began around the D&RG freight house spread to the north and east. The lumber and coal yards around the UPD&G depot provided plenty of fuel for the flames, and the depot was soon lost. Firefighters worked frantically to save the Antlers Hotel, but to no avail. This scene shows several UPD&G cars on the tracks near where the depot once stood. The ruins in the background were all that was left of the once proud Antlers.

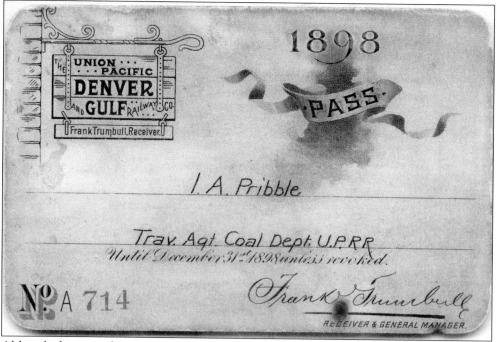

Although this annual pass was good until December 31, 1898, the Union Pacific, Denver & Gulf would not last that long. The death of John Evans the year before had set in motion the sale of the struggling line. A new railroad called the Colorado & Southern took its place. The C&S was the reorganization of the old UPD&G and the Denver, Leadville & Gunnison. It was officially chartered on December 20, 1898.

Four
DENVER & SANTA FE

Denied by the courts and the D&RG in its attempt to reach the silver mines of Leadville through the Royal Gorge, the Santa Fe began to tap into other regional markets. After it failed to acquire the D&NO, the Santa Fe made a decision to build its own tracks to Denver. To complete this task, the Denver & Santa Fe Construction Company was formed, and in 1887, the Santa Fe built a connection north from Pueblo to Denver. The Santa Fe established itself on the east side of Colorado Springs. Several years later, the Santa Fe acquired control of the Colorado Midland and obtained the interior mountain route it had sought for so long. The Pike's Peak Region now became a major transfer point for the two roads, and an arrangement was made that allowed the Colorado Midland to use the Santa Fe's depot in Colorado Springs. The arrival of the Santa Fe brought a new dimension to front-range railroading. Unlike the D&NO, the Santa Fe became a strong competitor of the D&RG. For Colorado Springs, the Santa Fe brought tariff wars, which were often both blessing and curse to merchants. It also brought a Fred Harvey lunchroom that cooked some of the best meals in town and a railroad that eventually became a nuisance to the residential neighborhoods of the East Side.

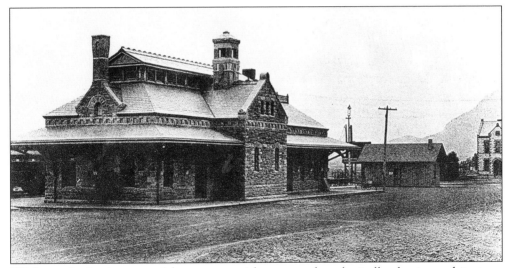

While not beckoning potential passengers with warm and aesthetically pleasing architecture, the Santa Fe's stone depot was as solid as it was functional. Its massive walls and castellated turret gave a sense of permanence to the building and the railroad it served. Built on what was then the eastern fringe of Colorado Springs, the depot was located just south of some of the city's most popular residential communities. This photo looks south and shows the west side of the depot, which faced Corona Street.

The competition that arose between the Santa Fe and the Denver & Rio Grande over access to the Royal Gorge created a rivalry that would last for decades. While struggling for dominance in the Colorado freight and passenger market, each railroad threatened to parallel the main line of the other. By 1887, the Santa Fe was making good on this threat and began building a line north from Pueblo to Denver. This extension was built by the Denver and Santa Fe, a construction company formed by the Atchison, Topeka & Santa Fe Railway to limit initial fiscal impact and liability. Once completed, the Santa Fe had direct access to Denver over its own right-of-way.

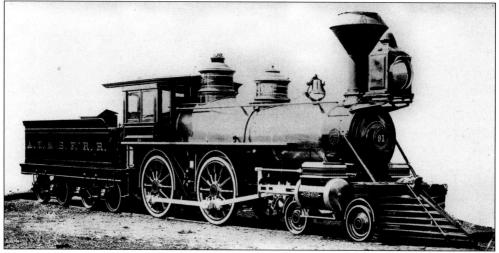

Santa Fe engine No. 91 was built by Baldwin in 1879. Its 4-4-0 wheel arrangement was well-suited for light passenger service. In 1900, it was renumbered No. 040 and became part of the Santa Fe's 037 Class.

Take a Trip to the Mountains of Colorado

VIA THE

Santa Fe Route

Finest Through Trains Between...

CHICAGO and
 DENVER, PUEBLO,
 COLORADO SPRINGS.

RESORTS OF COLORADO DESCRIBED IN BEAUTIFUL SOUVENIR BOOK

"A Colorado Summer"

ISSUED BY PASSENGER DEPARTMENT SANTA FE ROUTE.

Address: W. J. BLACK, G. P. A.,
TOPEKA, KANS.

J. P. HALL, Gen'l Agent, C. C. HOYT, City Pass. Agt.,
DENVER, COLO. COLORADO SPRINGS, COLO.

I. M. CONNELL, City Pass. Agt. G. W. HAGENBUCH, City Pass. Agt.,
CHICAGO, ILLS. KANSAS CITY, MO.

Serving popular Colorado destinations like Pueblo, Colorado Springs, and Denver kept the Santa Fe's advertising department very busy. While all of the wonderful sights and health benefits of Colorado were advertised in places like Kansas City and Chicago, handbills and advertising broadsides in Colorado were designed to influence passenger traffic to the East. This ad from the 1890s encourages potential Front Range patrons to travel via the Santa Fe to Chicago. It also references longtime Colorado Springs agent C.C. Hoyt. Hoyt was originally the Santa Fe agent in Emporia, Kansas. As the railroad moved west, so did he.

Railroads often published literature promoting the cities, states, and regions in which they operated. These pamphlets were made available to vacationers, informing them of the sights and destinations they might expect to see on a potential trip. The Santa Fe published many of these kinds of brochures. One of the most popular was called "A Colorado Summer." Its pages were filled with engravings and descriptions of such town as Pueblo, Denver, and Colorado Springs; local resorts and hotels; and even areas that were served by the D&RG.

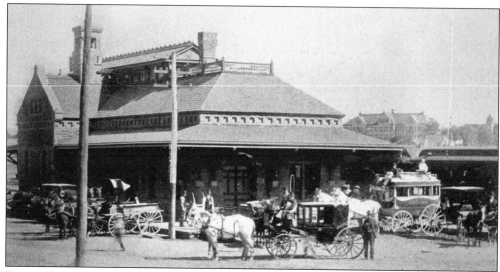

During the 1890s Colorado Springs became the major interchange point for the Santa Fe, especially with westbound traffic over the Colorado Midland. Upon its arrival, the railroad wasted little time in making its presence known. Not to be outdone by the D&RG, who had just built a new depot on the other side of town, the Santa Fe erected this handsome station just east of Corona between Huerfano and Pike's Peak Avenue. This busy scene shows the crowd of coaches, wagons, and hacks that tended to gravitate to the depot at arrival time. The buildings in the distance are part of the Colorado Springs Deaf and Blind School.

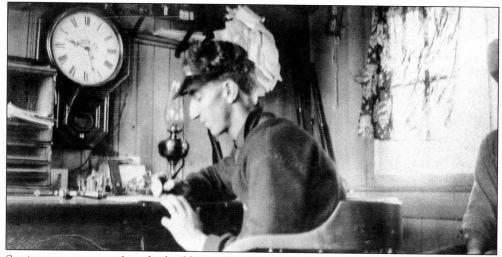

Station agents were often the backbone of a railroad. In larger depots, agents sometimes had assistants who helped to manage the daily affairs of the railroad. This was not always the case in smaller stations. In this photo Ed Willis is seen sitting by the telegraph in his agent's office. Willis started his career with the Santa Fe in Kansas as a carpenter. When his health began to fail, he transferred to Colorado, where he thought the fresh, mountain air would do him good. Willis worked in the Colorado Springs Freight Office and then moved south to Fountain, Colorado. The Santa Fe clock on that wall let employees know when the next train was due, and the rifles in the corner were a deterrent to train robbers or any other trouble the agent might run in to.

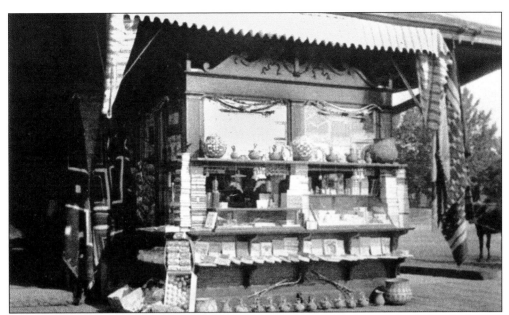

This photograph shows the Fred Harvey newsstand and souvenir shop at the Colorado Springs depot. It specialized in selling postcards, curios, and Native-American artifacts, and employed a newsboy who sold papers on arriving trains. With the arrival of the Santa Fe in Colorado Springs, rail service to the Pike's Peak Region more than doubled. In an attempt to attract more business, a portion of the depot had been allocated to the Fred Harvey Company. Harvey became a restaurateur in post–Civil War New York City. By 1870 he had gravitated to Kansas, where the West was still wild and the Santa Fe Railroad was still in its infancy. Harvey aligned himself with Santa Fe president Charles Morse. The result was the establishment of the Harvey House, a chain of restaurants and eating houses located at principal junctions and destinations along the Santa Fe's route. Harvey advertised good meals at reasonable prices. The economy and convenience of the Harvey House made the Santa Fe the railroad of choice with much of the traveling public. As the popularity of his company grew, Harvey built hotels, newsstands, and curio shops to compliment his lunchrooms.

Many railroads issued passes to their employees and those of other railroads they were affiliated with. The passes were good for free or reduced fares. This practice was also extended to the Fred Harvey Company. The passes were usually good for a year, issued to a specific person, and were countersigned by a railroad official. This pass was issued for the year 1900 and was good for 50¢ meals at Fred Harvey hotels and lunch counters.

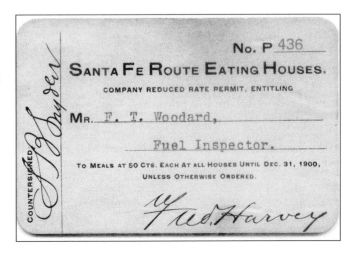

The Santa Fe yards at Colorado Springs were built to accommodate long strings of freight and passenger trains. As this late 1890s photo suggests, they also served as a temporary home for maintenance of way crews. When assigned to areas where sidings were not long enough to keep work trains, bunk and tool cars were often kept at larger facilities. From here, equipment and personnel could be shuttled to the work site as needed. Railroads often convened old boxcars and passenger equipment for its maintenance crews. In these portable hotels, "gandy dancers" would eat and sleep while laying track, building bridges, and making other necessary repairs.

As one of the major east-west carriers in Colorado, the Santa Fe was in direct competition with such notable railroads as the Union Pacific and the Chicago, Burlington & Quincy. Since it would not serve Denver directly until 1887, advertising efforts prior to this referenced passengers connecting to the Santa Fe in Pueblo. This advertising broadside from the 1880s emphasizes lower mileage and faster travel to the East. The Santa Fe advertised heavily in the mining towns served by the D&RG, knowing that many eastbound travelers would have to travel through Pueblo before getting to Denver.

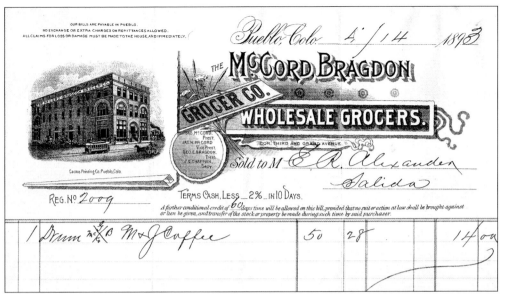

OUR BILLS ARE PAYABLE IN PUEBLO.
NO EXCHANGE OR EXTRA CHARGES ON REMITTANCES ALLOWED.
ALL CLAIMS FOR LOSS OR DAMAGE MUST BE MADE TO THE HOUSE, AND IMMEDIATELY.

Pueblo, Colo. 4 / 14 1893

THE McCORD BRAGDON GROCER CO.
WHOLESALE GROCERS.

JAS. McCORD,
Prest.
JAS. H. McCORD
Vice Prest.
GEO. E. BRAGDON,
Treas.
J. G. CHAPMAN,
Secy.

COR. THIRD AND GRAND AVENUE.

Sold to M E. R. Alexander
Salida

Cactus Printing Co. Pueblo, Colo.

REG. No 2009

TERMS CASH, LESS 2% IN 10 DAYS.
A further conditional credit of 60 days time will be allowed on this bill, provided that no suit or action at law shall be brought against
or lien be given, and transfer of the stock or property be made during such time by said purchaser.

| 1 Drum no⅞o M & J Coffee | | 50 | 28 | | 14 | 00 |

Although Colorado was far removed from the large manufacturers on the East Coast, the long reach of the Santa Fe into the Midwest helped keep local businesses well stocked. Many merchants in Pueblo and Colorado Springs shipped large volumes over the Santa Fe. In return, the railroad had an interesting way of rewarding some of its consignees. A few sidings along the line between Pueblo and Colorado Springs were named after some of the Santa Fe's larger customers. This 1893 invoice is from the Pueblo store of McCord and Bragdon. The Bragdon depot and siding north of Pueblo was named for the Bragdon family of which grocer George E. Bragdon was a part.

During the gilded age of rail travel, conductors were far more than just employees who plied the aisles asking for tickets. They greeted passengers as they boarded, and announced upcoming stops and interesting sights along the way. They also looked after children traveling alone, notified travelers of meal times, and served as the focal point for crew communications. Along with these and other duties, they ensured that only paying customers were on board, and when a rider was found without a ticket, they helped to expedite their departure. Like many railroads, the Santa Fe had its share of devoted employees. Such a man was conductor Harry Childs, a railroader for over 25 years. Childs worked out of several Colorado locations including Pueblo, Denver & La Junta. He was also a regular on the run through Colorado Springs. Sporting a uniform coat with embroidered "Santa Fe" lapels, Childs stands in front of the vertical oil tank near the Colorado Springs depot.

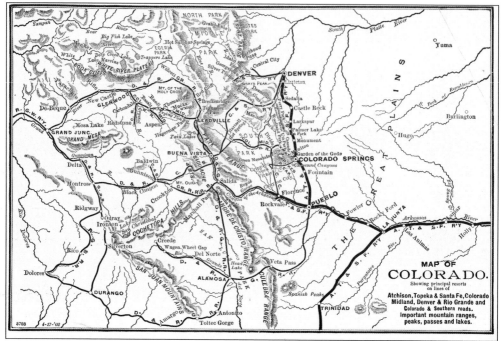

Although the area served by the Santa Fe was initially limited to southeastern Colorado, by the 1890s the Santa Fe had accessed the most populated regions in the state. The construction of the Denver & Santa Fe opened up a huge market in Colorado Springs and the acquisition of the Colorado Midland enabled the Santa Fe to benefit from the state's mineral rich interior. This map shows the routes of the Santa Fe in Colorado about 1895.

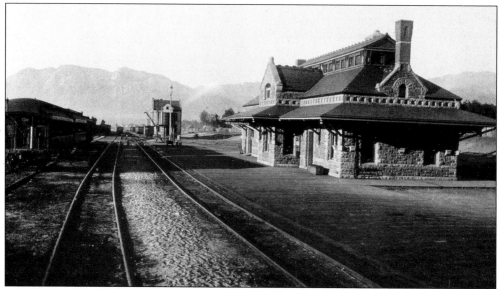

This photograph shows the north end of the Santa Fe's Colorado Springs depot. This end housed the baggage office and later the lunch counter and Fred Harvey souvenir shop. Arriving passengers only had to gaze south to be afforded a beautiful view of Cheyenne Mountain.

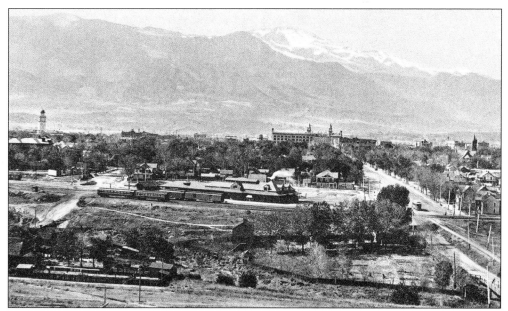

Although the Santa Fe acquired a sizeable piece of land for its yards in Colorado Springs, by 1900 when this photo was taken, the property was already starting to get encroached upon by a growing Colorado Springs. The tracks of the AT&SF once served as the eastern boundary of town and now it was just hurdle for real estate developers looking to build residential neighborhoods east of Shook's Run.

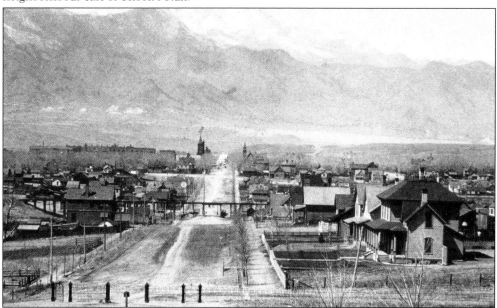

This photo, taken from the steps of the Colorado Springs Deaf and Blind School, looks westward down Kiowa Street. In the distance is the Santa Fe trestle. Wooden trestles like this one were typical of how the Denver & Santa Fe crossed a few of the more-populated thoroughfares north of the depot. The right-of-way followed close to Shook's Run and the uneven terrain required several trestles. Over time, some of these wooden structures were replaced with steel bridges.

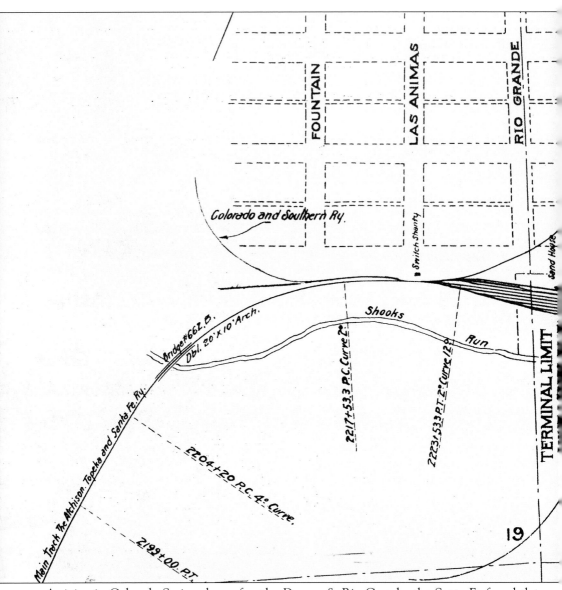

FOUNTAIN

LAS ANIMAS

RIO GRANDE

Colorado and Southern Ry.

Smith Shanty

Sand House

Shooks

Run

Bridge #662 B.

Dbl. 20'x10' Arch.

Main Track The Atchison, Topeka and Santa Fe Ry.

2217+53.3 P.C. Curve 2°

2223+53.3 P.T. 2° Curve 12°

2204+20 P.C. 4° Curve.

2199+00 P.T.

TERMINAL LIMIT

19

Arriving in Colorado Springs long after the Denver & Rio Grande, the Santa Fe found the western approach to the city already taken by its rival. As a result, the AT&SF established facilities on the eastern edge of town. The strip of land between South Wahsatch Avenue and Shook's Run was not ideal territory to build a railroad yard, but it was relatively flat and had

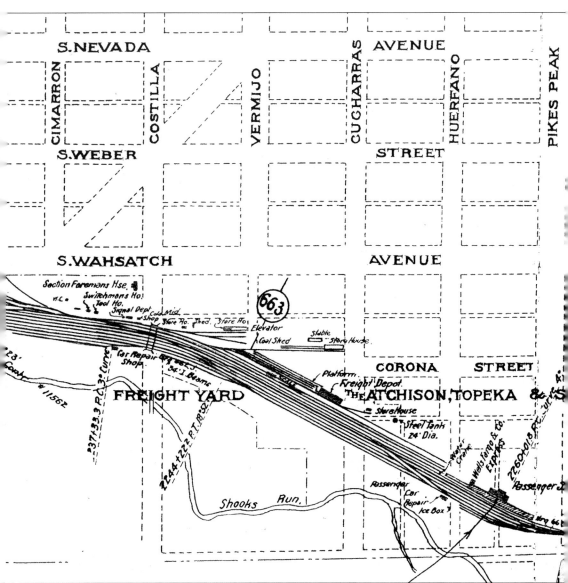

accessible water. At its height, the Colorado Springs yard was 10 tracks wide and extended from Fountain Street on the south to Pike's Peak Avenue on the north. (Courtesy of James R. "Jim" Jones.)

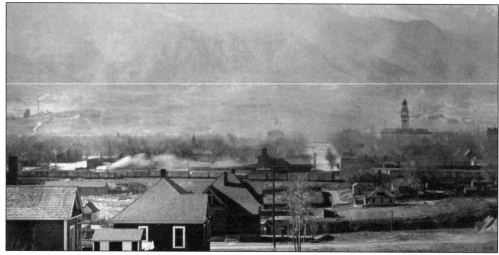

Once the Santa Fe became established in Colorado Springs, the land to the east of Shook's Run became more popular with local real estate developers. By the late 1890s the Pike's Peak Addition along with Goshen and Bennett's subdivisions had already started to take shape. This photo, taken from a point near the intersection of Vermijo and Prospect, looks west towards the one-story bungalows along El Paso Street. In the distance are the Santa Fe yards and elevator of the Economy Grain Mill.

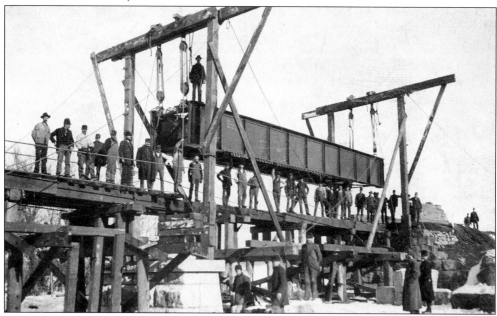

This photograph from the late 1890s shows a Santa Fe building and bridge crew erecting a new span across one of the residential streets north of the Colorado Springs depot. In the decade after its construction, a growing Colorado Springs expanded further to the east. By 1900, tracks of the Santa Fe ran through several residential neighborhoods. The noise and congestion generated by the railroad was a constant source of friction between the railroad, the city, and its inhabitants. As a result, the railroad made an effort to limit the whistle signals of its engines going through town, kept its right-of-way up to date, and, as this scene suggests, accommodated pedestrian and wagon traffic as much as possible.

Once purchased, a traveler's ticket was a map to their destination. Passengers who were taking a long journey usually received long strip tickets. These tickets were usually routed over several railroads and as each railroad was reached, a conductor would tear off that portion of the ticket. Although this ticket was issued in conjunction with the narrow-gauge Florence & Cripple Creek Railroad, the passenger probably traveled via the Colorado Midland to the Santa Fe depot in Colorado Springs. The envelope that accompanies this ticket is indicative of the Santa Fe's practice of advertising its more scenic and exotic destinations.

Security was a great concern to early railroads. To ensure the safe passage of trains, switches that diverged off the main line needed to be locked. These security methods were found in many other branches of railroad service. Buildings, freight cars, strong boxes, and tool racks were just a few of the areas railroads needed to protect. As a result, railroads ordered locks by the thousands. Ordering at such volumes, railroads could often induce lock companies to cast the name or the initials of the railroad into the face of the lock. Such a method of identification left little doubt to ownership. This photo shows an example of a brass Santa Fe general-purpose lock. It was manufactured by the F.C. Simmons Hardware Company under their "Keen Kutter" brand.

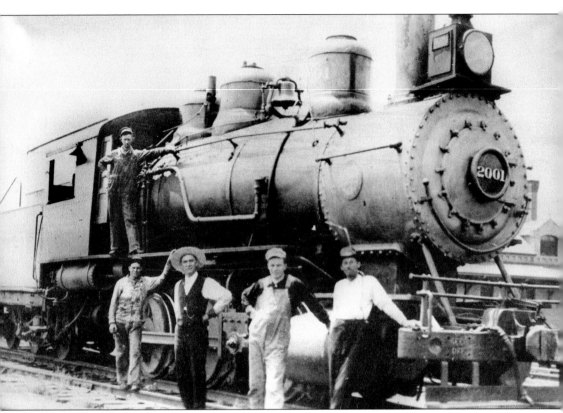

The several railroads using the facilities at Colorado Springs created a large amount of inbound and outbound traffic. Much of the staging of this traffic was done by small switch engines like this one. The volume of cars that needed to be consolidated and transferred prompted the Santa Fe to assign a permanent switch engine and crew. Around the turn of the century, this switch engine was AT&SF No. 2001. Although switching operations did not have the glamour of freight and passenger service, it was vital in the interchange process and the accommodation of local customers. This switching crew, consisting of engineer, fireman, and a front and rear brakeman, pose in front of No. 2001. In the background is the extension built on the Santa Fe depot in 1899.

Five
COLORADO MIDLAND

Compared to some other railroads in the Pike's Peak Region, the Colorado Midland was a bit of a late bloomer. Prior to the mid-1880s, Ute Pass had only been accessible by stagecoach and wagon. By 1883, with the mines of Leadville in full production, a desire to build a railroad through Ute Pass had developed. A group of local businessmen attracted the attention of mining mogul J.J. Hagerman, who saw promise in the idea of a railroad that would connect Colorado Springs with the silver mining districts to the west. By 1887, the Colorado Midland was a reality. It was the first railroad to use the Pike's Peak Region as a terminus, and its facilities in Colorado City had a great impact on the local economy

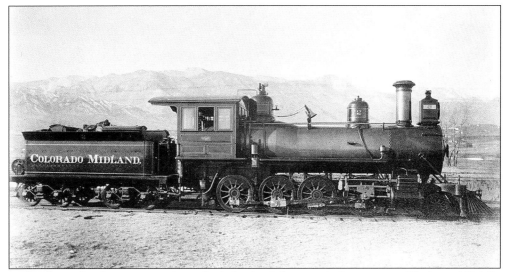

Colorado Midland engine No. 2 was built by the Schenectady Locomotive Works in 1886. In this photo, the "Two Spot" poses in Colorado Springs soon after being delivered from the builder. The landscape and lack of buildings in the background suggests that this photo may have been taken in the former D&NO yards. With no place to initially store its first order of locomotives, the Colorado Midland made arrangements to park its engines near Moreno Street on the tracks of the Denver, Texas & Gulf.

Prior to the mid-1880s this wagon road was the major thoroughfare from Manitou west up Ute Pass. During this time, many tourists and travelers heading into the mountains west of Colorado Springs took the stage up the Ute Pass Wagon Road. This photo shows Rainbow Falls, one of the many scenic spots around Manitou. As time and technology progressed, the heavy use of this road would decline. By the late 1880s, the trains of the Colorado Midland would also run through Ute Pass. (Photo by H.H. Buckwalter.)

As a pioneer of the Colorado City area, Anthony Bott would benefit greatly from the growth of the Pike's Peak Region. Bott was a farmer and merchant and held several large tracks of land below Colorado City on the south side of Fountain Creek. As a result of the previous projection of the D&RG's Manitou Branch, Bott was in possession of the most likely route that another railroad might take. In July of 1886, Bott was approached by officers of the newly formed Colorado Midland Railway. When Bott was informed of the intent of the Colorado Midland to establish a large yard and maintenance facility at Colorado City, he began to sell off part the property he owned along Fountain Creek. This property would become the right-of-way and yards area for the Colorado Midland Railway.

Railroad construction was hard work, and the mountains and jagged terrain of Colorado made it even more difficult. In the case of building the Colorado Midland, this difficulty fell upon men like the O'Brien family. They helped build the railroad west out of Colorado Springs and stayed with the crews as far as Leadville. Once in Leadville, the three brothers (top row, from left to right), Michael, Frank, John, and brother-in-law Tom Rees, got into the mining business. It was just as difficult but much more lucrative work than railroading, and the brothers made enough money to send east for their families.

Like many new arrivals to the Pike's Peak Region, James J. Hagerman had come to find the cure for tuberculosis. When he set up residence in late 1884, Hagerman was already a rich man, but his association with Colorado Springs would make him even richer. Hagerman was approached by a group of Denver and Colorado Springs businessmen interested in building a railroad from Colorado Springs to the silver mines of Leadville and Aspen. Hagerman took great interest in this project and in 1885, was elected president of the Colorado Midland Railway. While he had come to Colorado to rest and not run a railroad, J.J. Hagerman took his new job very seriously and helped make the Colorado Midland Colorado's first standard-gauge railroad to breech the Rocky Mountains.

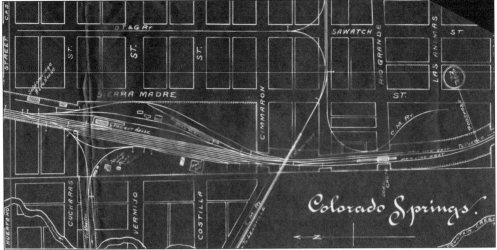

This 1890 station map of Colorado Springs illustrates the congestion caused by three different railroads and the labyrinth of tracks across the southwest portion of the city. In the middle-left portion of the photo are the D&RG yards, while the Manitou Branch fades off into the bottom-left corner. The northern length of Sahwatch Street is dominated by the tracks of the Denver, Texas & Gulf. The bottom center shows the main line of the Colorado Midland Railway. Initially, the Colorado Midland formed a tentative agreement with the DT&G to use their tracks into Pueblo. However, the Midland later opted to use the tracks and the facilities of the Santa Fe but continued to use the Moreno Street corridor to gain access to the Santa Fe station.

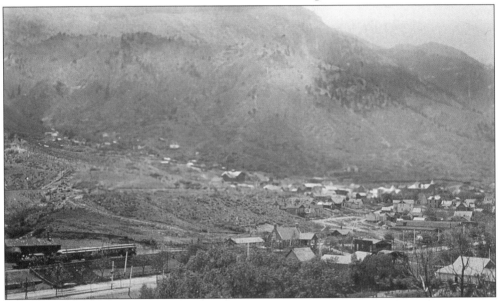

Once the money had been secured to begin the grading of the Colorado Midland, contractor's crews wasted little time in getting the right-of-way ironed. By early 1887, the town of Manitou had two railroads. This photo plainly illustrates both grades as they enter Manitou from the east. The grade and train in the bottom of the photograph is that of the D&RG, while the tracks of the Colorado Midland are higher above. Although a tough walk for a baggage-laden D&RG passenger, most of the Rio Grande traffic to Manitou was local, with through connections taking place in Colorado Springs. (Photo by William Henry Jackson.)

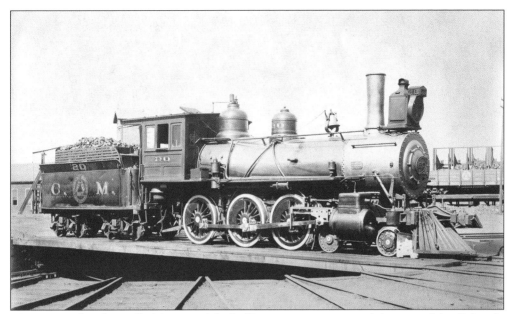

Mountain railroading called for a good deal of locomotive service, and the men of the Colorado Midland took great pride in keeping their engines clean and well maintained. Built by the Schenectady Locomotive Works in 1887, a newly rebuilt 4-6-0 No. 20. pauses on the Colorado City turntable, ready for another passenger run. (Photo by H.H. Buckwalter.)

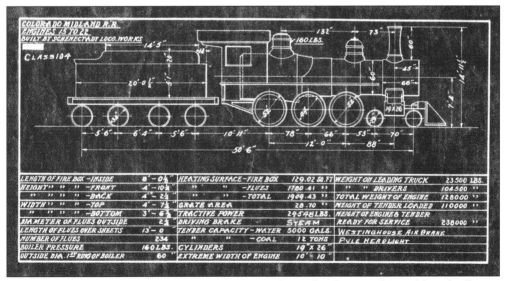

Engines No. 15 through 22 were part of the Colorado Midland's 104 Class. Although all were originally delivered with 60-inch drivers, No. 15, 20, and 22 were later fitted with 58-inch drivers. The 104 Class is based on the weight on the drivers, an approximate 104,000 pounds. Over 100 years ago, blueprints like this were often consulted by railroad employees, and those that have survived are equally valued by railroad modelers and collectors.

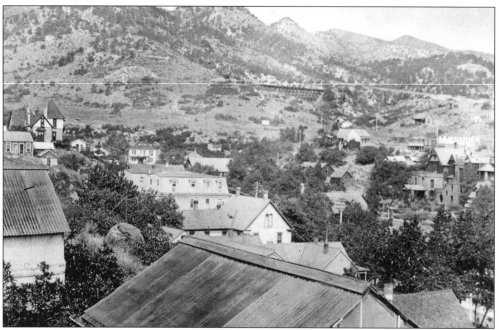

The Colorado Midland was not able to access the business district of Manitou and still gain the elevation it needed to tackle Ute Pass. Instead, the railroad was built along the heights to the south and west of town. This photo taken from the west end of Manitou looks west. In the distance are the tracks of the Colorado Midland, crossing a trestle and heading towards Ute Pass.

Once the railroad was completed, the image-conscious Colorado Midland looked for a herald that the public could identify with. By the late 1880s, many tourists knew about Colorado Springs and its mountain scenery, and the passenger department wisely decided to include Pike's Peak into their new logo. This 1888 advertisement incorporates the "Pike's Peak Route" logo with places like Manitou, Green Mountain Falls, and several other popular destinations along the line.

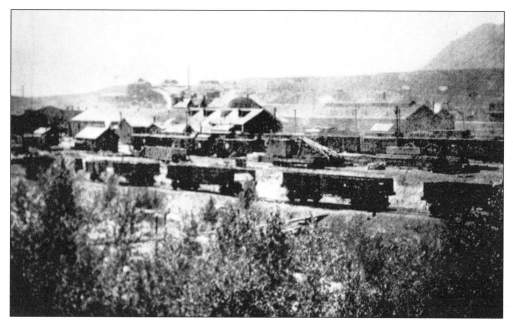

This photo shows the extensive facilities built by the Colorado Midland just south of Colorado City. The railroad's organizers saw the potential that lay in the farmland along Fountain Creek. This area was relatively flat, had easy access to water, and there were several large population centers from which to draw employees. By the late 1880s the Midland had erected a number of shops and buildings, including a large stone roundhouse. The photo was taken from a point near Fountain Creek and looks to the southeast showing the Carpenter and Coach Shop, General Offices, and the corner of the Roundhouse.

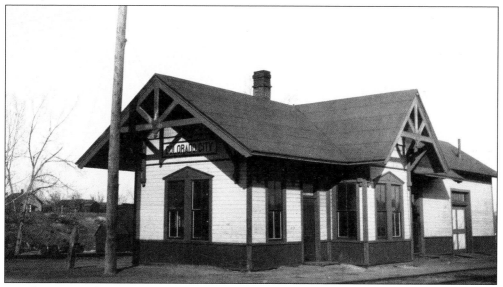

Standing in stark contrast to the large car shops and roundhouse nearby, the Colorado City depot was located at the west end of the Colorado Midland classification yard. Despite its small size, the depot served the community well. This was a local station as most of the through-passenger traffic originated at the Santa Fe depot in Colorado Springs. (Photo by William Wood.)

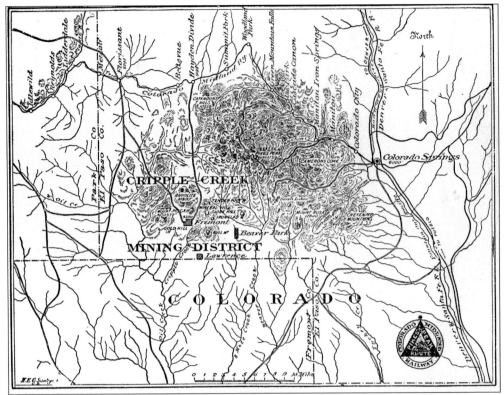

In the early 1890s the Pike's Peak Region was hit with an epidemic of gold fever. The first gold rush occurred in Florissant but interest soon subsided when the gold was found to be iron and copper deposits. Naturally, when rumors of Bob Womack's gold discovery began to surface, they were met with skepticism. However, Bob was persistent, and his mine in Cripple Creek soon became a legend. The excitement was a boom to the Colorado Springs economy and helped fill the coffers of the Colorado Midland. This 1892 map shows the town of Fremont, as Cripple Creek was then known, and the route of the Colorado Midland. Although a direct connection to the Midland would not occur for three more years, suburban trains were run between Colorado Springs and the stations of Divide and Florissant. From these points, stages and freight wagons would carry passengers and ore to and from the District.

By the 1890s, the concept of "The West" had caught the imaginations of many. The geography, wildlife, and indigenous peoples of the Rocky Mountains became popular with tourists—a condition the Colorado Midland was quick to promote. One of the most interesting connections made by the Midland was with the Native Americans, whose likenesses often appeared on passes, timetables, posters, and other mediums of advertising.

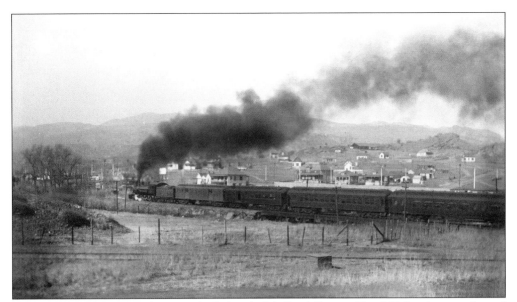

Pulling the Colorado-Utah Limited, Colorado Midland Engine No. 201 heads a westbound passenger Train No. 5. The small Colorado City suburb in the background was once called "Areusdale" while the large building in the distance near the rock formation was part of the Colorado City Chautauqua.

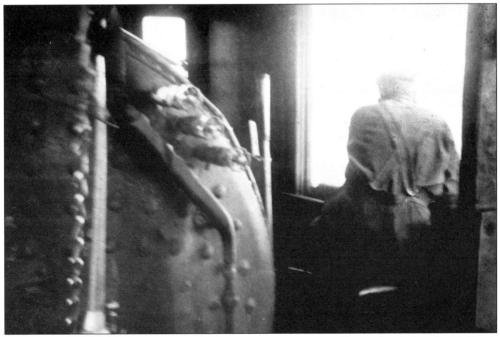

Interior shots of old locomotives are not very common, especially on the Colorado Midland. The head brakeman on a Colorado Midland train took this candid photograph of engineer Charlie Oren, shown here at the throttle of 2-8-0 No. 50. Men like Oren and his fireman William Wood worked very demanding jobs in all weather conditions. Their dedication embodied the spirit of standard-gauge mountain railroading.

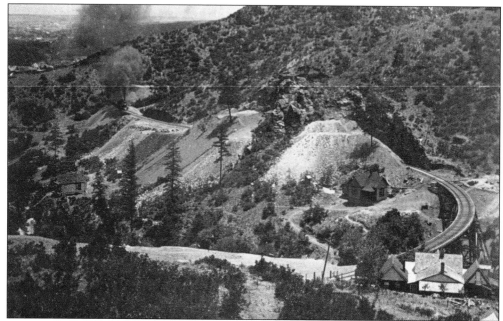

Unlike some railroads where tunnels were only found in deep and remote mountain trackage, the first tunnel on the Colorado Midland was in plain view of civilization. The smoke in this photo is from a Colorado Midland engine that had just cleared Tunnel No. 1. From here the engine passed through Tunnel No. 2, and spanned Englemann Canon via the Iron Springs Trestle. (Photo by W.H. Jackson.)

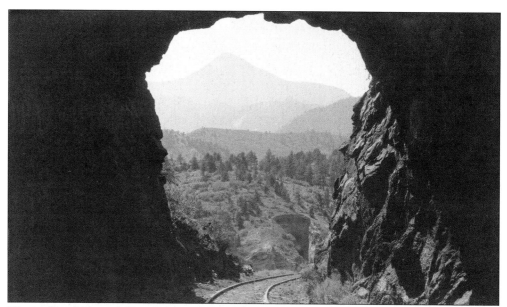

The walls of Tunnel No. 4 formed the border for one of the most picturesque sights on the Colorado Midland. This photograph looks east towards Tunnel No. 3 and shows the majestic Cameron's Cone. The peak was named for Gen. Robert Cameron, a one-time associate of General Palmer and short-lived director in the Colorado Springs Company. (Photo by Ernie Peyton.)

Six

CHICAGO, KANSAS & NEBRASKA

Of all the standard-gauge railroads built into Colorado, perhaps the Chicago, Kansas & Nebraska Railway is the least known. The CK&N arrived in Colorado Springs well after the D&RG and D&NO and on the heals of the Colorado Midland and the Santa Fe. Its anticlimactic appearance in the Pike's Peak Region drew little attention from the public and the press, which may go a long way in explaining the lack of photographic documentation on the CK&N. Like the Denver & Santa Fe, the CK&N was a construction company and was charged with the extension of track for the larger parent company. The CK&N was incorporated on March 19, 1886, and was chartered with building Rock Island through Kansas and into Nebraska, Colorado, and Indian Territory. The CK&N finally arrived in Colorado Springs on August 10, 1888, where the small railroad town of Roswell had been recently established.

On much of its equipment and rolling stock, the CK&N incorporated the use of the Great Rock Island Route logo. However, on paper literature it often used this plain but functional herald.

By the early 1880s, the evolving Chicago, Rock Island & Pacific Railway was contemplating a westward expansion. Fueled by an influx of immigrants and the silver boom in Colorado, Rock Island looked to cash in on Manifest Destiny. Hoping to attract westbound passengers, ads like this one began to appear in Rock Island timetables of the 1880s.

No. 495

INCORPORATED UNDER THE LAWS OF THE STATE OF KANSAS.

Shares.

The Chicago, Kansas & Nebraska R'y Co.

AUTHORIZED CAPITAL, $30,000,000.

Shares $100 Each.

WHOLE NUMBER OF SHARES, 300,000.

THIS CERTIFIES, That

is entitled to Shares, numbered from

to inclusive, of the Capital Stock of THE CHICAGO, KANSAS & NEBRASKA RAILWAY COMPANY. Said stock is transferable only upon the books of said Company by the holder above named, or his attorney in fact, upon presentation and surrender of this Certificate.

IN TESTIMONY WHEREOF, The said Company has caused this Certificate to be signed by its President, and attested by its Secretary, and its corporate seal to be hereto attached, this day of 188

Attest:

President.

Secretary.

Established in the spring of 1886, the purpose of the Chicago, Kansas & Nebraska Railway was to build a railroad west through Kansas towards Colorado, with branches to Nebraska and Indian Territory. There were actually two CK&N companies. The CK&N of Nebraska was responsible for construction in that state and the CK&N of Kansas was responsible for building west toward the Colorado border. The two would later be consolidated with a total authorized capital of $30 million. The money to build these extensions came from the sale of stock. Stock certificates like this one helped raise money needed for construction and the purchase of equipment. While not issued, this certificate was signed by the CK&N's president, Marcus A. Low.

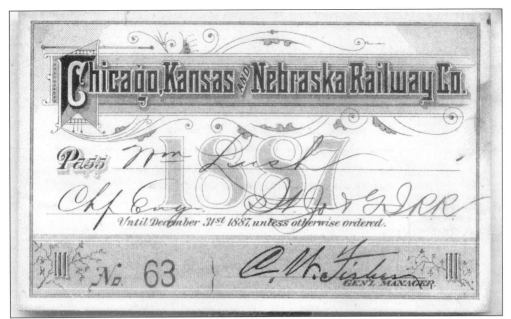

Although it was chartered the year before, 1887 was the first full year of operation for the CK&N and it was also the year that much of the Kansas and Nebraska construction took place. Unlike some railroad construction companies, the CK&N continued to operate as a separate entity even after the line was completed. For five years, the CK&N operated its own engines and rolling stock and even issued passes like this one.

The track of the CK&N entered Colorado in the spring of 1888 and continued to head west throughout the summer. Although less demanding than the complexities of mountain railroading, the construction crews still had their problems. The CK&N had to cross three different railroads on its journey west from the Kansas border. The first was with the Union Pacific in Limon, the second with the DT&G in Falcon, and finally the tracks of the Santa Fe just east of the terminus in the newly built Colorado Springs suburb of Roswell. This vellum track profile shows how the Rock Island crossed under the Santa Fe main line north of Colorado Springs.

Articles of Agreement, made and entered into this fifteenth (15th) day of February, in the year eighteen hundred and eighty-eight, *by and between* **The Denver and Rio Grande Railroad Company,** a corporation organized and existing under the laws of the State of Colorado, hereinafter referred to as the "Denver Company," and **The Chicago, Rock Island and Colorado Railway Company,** a corporation organized and existing under the laws of the same State, hereinafter referred to as the "Chicago Company," WITNESSETH: .

PARTIES.

First. The Denver Company owns and operates a railway with appurtenant property, a portion of the main line of which extends from Denver through Colorado Springs to South Pueblo, all in the State of Colorado; and the Chicago Company owns a railway which is being constructed from the Western boundary of the State of Kansas, at which point it will connect with the Chicago, Kansas and Nebraska Railway, to the city of Colorado Springs, above mentioned.

RAILWAYS OPERATED BY EACH PARTY.

Second. The interests of both parties and of the public will be promoted by the establishment and operation of a through line of railway between all the points on the line of the railway of the Denver Company between and including Denver and South Pueblo, and all points on the line of railway which will be operated by the Chicago Company and on the system of railways of which the Chicago Company will form a part.

Therefore, in consideration of the premises, and of the several covenants, promises and agreements hereinafter set out, *the parties do covenant, promise and agree,* to and with each other, as follows:—

Even before the rails of the CK&N arrived in Colorado Springs the railroad's officers were looking towards securing their future. At that time, the Pike's Peak Region was only the terminus for the Colorado Midland. While this connection was profitable from an east-west perspective, the Rock Island was also interested in accessing north-south traffic. This photo is the first page of an agreement signed on February 15, 1888 between the Denver & Rio Grande and the Chicago, Rock Island & Colorado, a subsidiary of the CK&N. One of the stipulations of this agreement gave the CK&N access to the D&RG's passenger facilities in Colorado Springs.

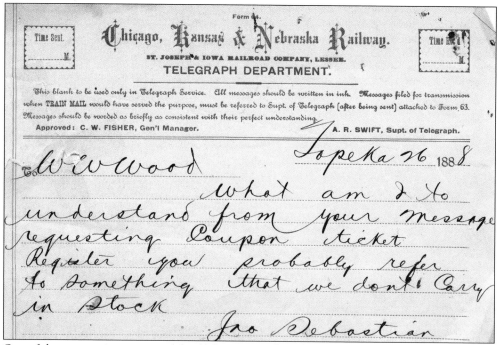

One of the greatest inventions of the 19th century, the telegraph was quickly adopted by many railroads. While the telegraph was often used in train service, it was also an effective tool of the passenger department. This CK&N telegraph concerning tickets sales was sent from John Sebastian, general passenger agent in Topeka, to William Wood, the CK&N's city passenger agent in Colorado Springs.

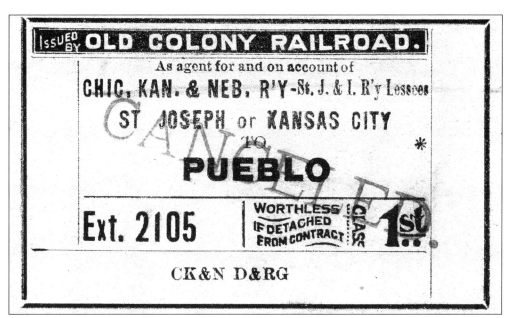

In the 1880s, long railroad trips usually required travel over several railroads. As a result, the passenger needed a ticket to ride on each of these railroads. Sometimes referred to as strip tickets, these tickets often consisted of multiple coupons, which would be honored by each of the participating railroads. This 1889 ticket originated in Boston for the Old Colony Railroad. The western leg of the journey was completed over the CK&N and the D&RG.

The initial relationship that the CK&N had with the Denver and Rio Grande can be seen in this 1889 timetable. Once in Colorado Springs, a passenger traveling over the Rock Island could travel to Pueblo, Denver, or a number of other Colorado destinations.

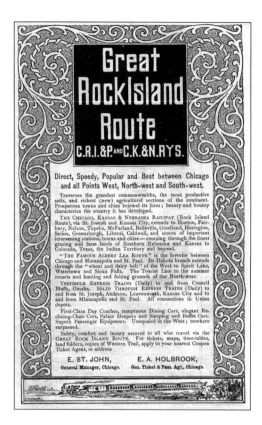

By 1890 when this advertisement appeared, the CK&N was still an entity, but was often overshadowed by the larger and more easily identified logo of the Rock Island Route. In another year, reference to the CK&N would disappear for good.

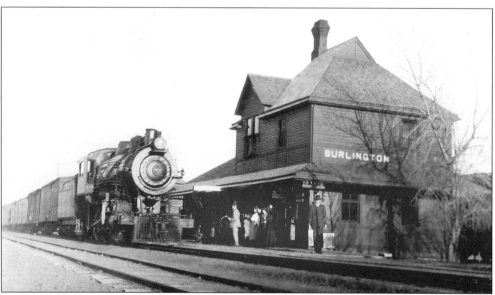

One of the first depots built by the CK&N in Colorado was this structure at Burlington. The freight and passenger offices along with the waiting room were on the first floor while the agent and his family lived upstairs. This was a standard-style station and indicative of many of the depots built by the CK&N as it pushed west to Colorado Springs in 1888. Well constructed and with an emphasis on functionality, some of these depots would last into the 1930s.

When the CK&N arrived in Colorado Springs on August 10, 1888 a railroad town of sorts had already been established. Andrew Lawton, a local real estate speculator, joined forces with CK&N president Marcus Low in establishing the town of Roswell. The town was named for Roswell P. Flower, a New York Congressman and a director of the Rock Island. While the residential area and the railroad facilities were expected to grow, changes in trackage rights into Denver and other factors ensured that Roswell would remain a small community.

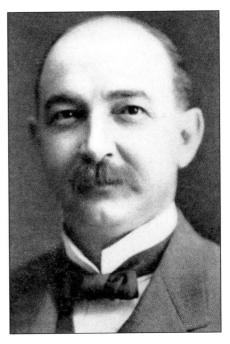

The CK&N selected a very able man to head up its Colorado Springs offices at 12 East Pike's Peak Avenue. William Wood had come east with the railroad in 1888 and brought with him a great deal of experience. During his early years in Colorado Springs, Wood lived the life of a bachelor and kept a room at the Rock Island's Grier Hotel just north of the D&RG Depot. Wood married, and in 1911 left Colorado Springs to become the Rock Island agent in Pueblo.

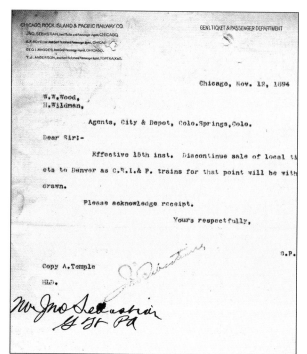

A trackage agreement with the Union Pacific in 1889 changed how Rock Island passenger service was routed in and out of Denver. Originally, through-passenger trains were routed to Denver upon arriving in Colorado Springs. The new agreement with the UP allowed passengers to transfer in Limon. This saved the passengers time and it saved the Rock Island money. As advantageous as this arrangement was for the railroad and its patrons, it would greatly diminish the railroads reliance on local support. Over the next few years, Rock Island passenger service over the D&RG fell off dramatically, and in mid-November 1894, City Agent William Wood and D&RG Depot Agent Harry Wildman received this notice to discontinue local ticket sales.

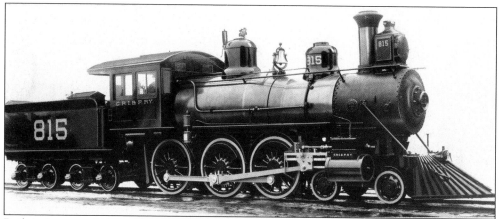

Built in January of 1892, Rock Island Engine No. 815 was a major effort by the railroad to "dress up" its passenger trains. No. 815 and the other engines in her class were a great improvement over the 4-4-0s that had been used on the CK&N. The Rock Island spent much of the late 1880s building railroads and extending its routes. By early 1892 this expansion program left the railroad in desperate need of additional passenger locomotives. In an effort to fill the void in its engine roster, they turned to the Brooks Locomotive Works and placed an order for six 4-6-0 engines.

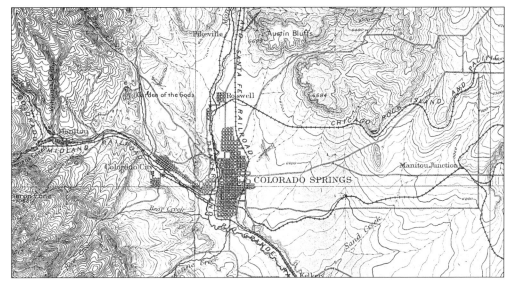

This 1894 map illustrates how the city of Colorado Springs was becoming a railroad hub. The tracks of the Santa Fe and D&RG are on a north-south axis while those of the Rock Island and the DT&G enter town from the northeast and southeast, respectively. To the west are the D&RG's Manitou Branch and the mainline of the Colorado Midland Railway. Also shown is the proximity of Roswell to Colorado Springs.

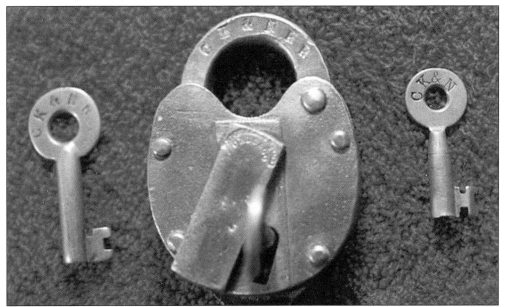

Like any other railroad, the CK&N had a need to keep its right-of-way, structures, and the freight it was hauling secure. One switch that was improperly thrown could spell disaster for a train, and railroads always emphasized the safety of its patrons, property, and their employees. One method of security was the use of locks. Brass locks and keys were preferred as they were less susceptible to the elements and usually had the initials of the railroad stamped or cast into the hardware to denote ownership. From left to right are a handcar key, a switch lock with switch key, and a car lock key. Since it was an early railroad that only lasted five years, hardware from the CK&N is extremely rare.

During railroad construction, emphasis was often placed on completing the line as expeditiously as possible. Sometimes bridges and trestles were installed quickly, with the intent of coming back later when time was not a constraint and there was sufficient revenue on hand to facilitate more permanent structures. This brass bridge plate pays tribute to such a maintenance philosophy. Installed over a local dry creek in 1892, the plate was affixed to a steel bridge that replaced a wooden trestle built only a few short years before.

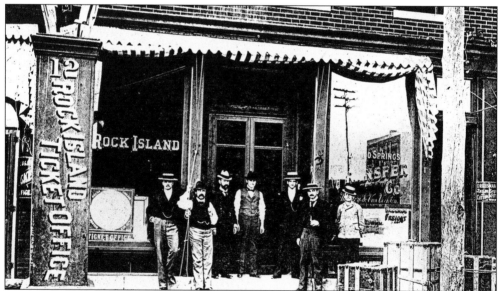

Many railroads used elaborate advertising pieces to make sure that their city ticket offices would not go unnoticed. The Rock Island was no exception to this and adorned the front of their office at 12 East Pike's Peak Avenue with a pair of horseshoes mounted on a tall wooden pedestal. Posing beside this monument to local transportation is a group of railroad employees taking a break from their daily activities. The Rock Island shared its offices with E. Smith Wooley and Abraham Van Vecten, proprietors of the Colorado Springs Transfer Company. (Photo by Horace Poley.)

This mid-1890s view of Monument Creek, taken from a point just south of the town of Roswell, illustrates the distance between the two towns. In the years to come, a fine residential area was built on the east banks of the creek north of Colorado College, and portions of the creek bed later became part of Monument Valley Park. (Photo by William E. Hook.)

By 1898, the CK&N had ceased to exist as a corporation, but the Rock Island's presence in Colorado was still very much alive. The sharing of the Colorado Springs depot with the D&RG afforded an easy connection to arriving passengers. It also prompted the Rock Island's passenger department to publish regional brochures. Entitled "Manitou and the Mountains," this tourist pamphlet expounded on the sights and scenery that awaited Rock Island passengers.

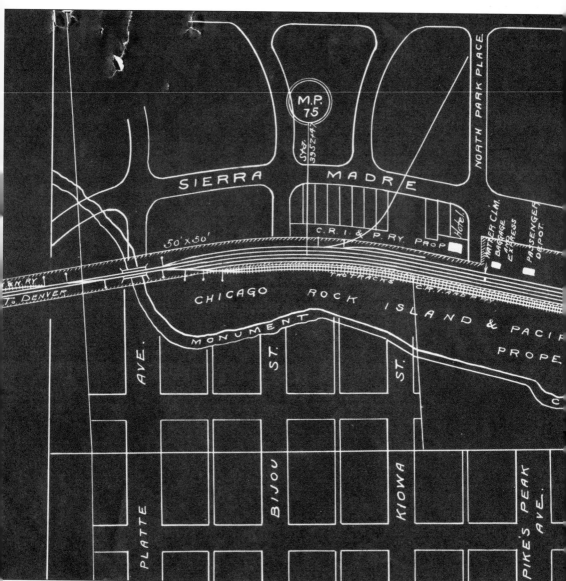

This 1891 blueprint shows the joint Rock Island–D&RG passenger facilities along Sierra Madre Street in Colorado Springs. Although engine servicing would take place at Roswell, passengers were discharged and picked up at the D&RG depot. The Rock Island-owned property on both sides of the tracks and also built a hotel just north of the Rio Grande baggage and express building.

Seven
MANITOU & PIKE'S PEAK

The Manitou & Pike's Peak Railway was unique among the railroads of the Pike's Peak Region. Unlike other Colorado railroads that were reliant on population patterns, industrial output, and mineral discoveries, the M&PP used tourism and geography to create its own market. Since the late 1850s, western pioneers had gazed in amazement at the dominating heights of Pike's Peak. Some were so enchanted with its beauty that they felt compelled to climb to its peak. By the mid-1870s, these mountain climbers had created a small industry in the town of Manitou. Trips up the side of the mountain gave way to the construction of a wagon road. In 1889, construction finally began on the Manitou & Pike's Peak Railway. While it was only a little less than nine miles long, bad weather and the extreme altitude created delays in completing the line. Inaugural service to the old U.S. Army Signal Station at the summit began in June 1891, and the M&PP has been delighting tourists ever since.

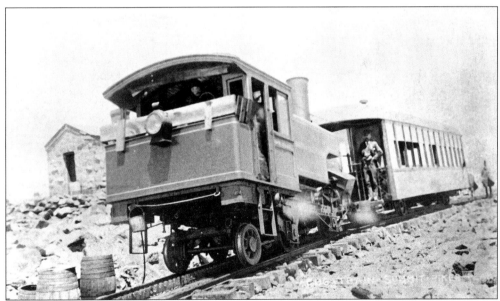

In this early photo taken at the summit house, the crew of Engine No. 1 prepare for the trip back down to Manitou. The conductor waits on the platform of the passenger coach while the engineer peers over the locomotive's fuel bunker. The first three locomotives of the M&PP were named as well as numbered. Engine No. 1 bore the name of "John Hulbert," in honor of one of the railroad's original promoters. (Photo by W.E. Hook.)

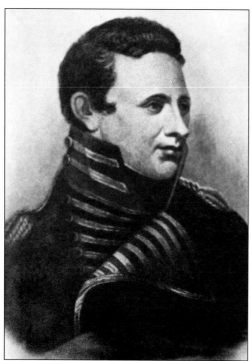

One of the first Americans to explore the upper regions of the Arkansas River was Lt. Zebulon Pike. During his 1805–1806 expedition, Pike and his part of 26 soldiers explored portions of what would later be called Colorado. He is also credited with having discovered Pike's Peak, but arrived at its base too late in the season to completely ascend to its top. Pike would never know the fame of his expedition or the mountain that would bear his name. Seven years and several promotions later, Brigadier General Pike was killed during the assault on York, Canada, during the War of 1812.

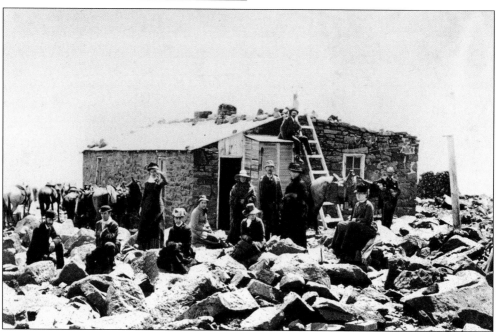

The establishment of Colorado City (and later the founding of Colorado Springs) inspired a greater interest in Pike's Peak. In the early 1870s the U.S. Signal Corps established a weather-observation station at the summit. Equipped with basic weather instruments, the signalmen used a telegraph to communicate their readings to the outside world. Built of thick stone walls to ward off heavy snows, this observatory was both office and barracks for the soldiers that were stationed there. (Photo by James Thurlow.)

Even before the establishment of Colorado City, curious tourists and explorers had a desire to reach the top of Pike's Peak. One of these original hearty climbers was Mrs. Julia A. Holmes who, in 1858, was the first woman to ascend the mountain. With the growth of Manitou, a "burro livery" was established where visitors were provided with four-legged mountain climbing gear. This photo shows a group of 1870s adventurers during their climb up the Pike's Peak Trail. (Photo by James Thurlow.)

Oddly enough, one of the first events that brought Pike's Peak into the American consciousness never even occurred. With the telegraph being the weather station's only communication with the outside world, Sgt. John O'Keefe began to use the wires for his entertainment. O'Keefe and his wife Nora reported a story of their baby daughter Erin, who had allegedly been eaten by "mountain rats." The hoax duped many, but in fact, the couple never had a daughter named Erin in the first place. This tongue-in-cheek photograph records the "funeral" for baby Erin O'Keefe.

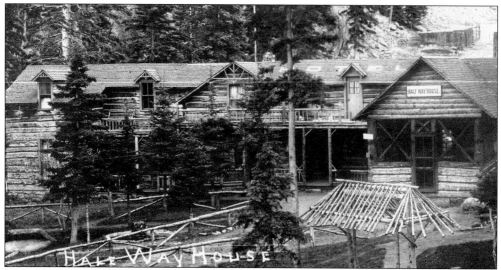

One of the first businesses to thrive along the Pike's Peak Trail was a small cabin owned by Tom Palsgrove. Originally meant to be a summer cabin for his family, Palsgrove soon took to serving refreshments to passing hikers. As more tourists came, a hotel called the "Halfway House" was opened. In 1888 the building was expanded and by 1890 when the M&PP arrived, the hotel was doing a brisk business. Palsgrove originally operated with a no-frill fare, but the unheated room and outhouse did not deter adventuresome tourists.

Some early Manitou visitors wanted to enjoy nature by themselves and at their own pace. Seeking more rugged accommodations, they built "cottages" along the base of Pike's Peak not far from Halfway House. In the background of this photo, one of these primitive cabins can be seen along with its occupants and the ever-popular burro.

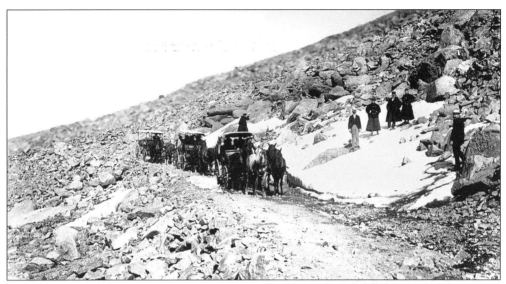

The idea of building a trail up Pike's Peak goes back to General Palmer's Colorado Springs Company and his chief engineer, E.S Nettleton. A burro path was built up the mountain and while it was later expanded, it could not support wagon and carriage traffic. During the 1880s the Pike's Peak Toll Road was built. The road began near Cascade where Colorado Midland passengers got off the train and boarded carriages. The horse-drawn carriages would sometimes only ascend halfway, where tourists were transferred to the more adaptable burros for the remainder of the trip. This image shows a party of sightseers who have paused by a snow bank for their photo (Photo by W.E Hook.)

Unlike some Colorado railroads, whose directors were more familiar with Wall Street than with the Rocky Mountains, many of the directors of the M&PP were local businessmen. Such a man was David Moffat. Shown in this photo, Moffat was a Colorado pioneer and had significant experience in the banking industry and in helping to build and operate local railroads.

Burros not only helped to transport many early tourists up Pike's Peak; they also helped to build the railroad. The hearty constitution of the burros made them much better suited to haul construction supplies at higher elevations. This humorous photo shows a burro loaded down with a box of dynamite and all the hand tools it took to grade the right-of-way. (Photo by W.E. Hook.)

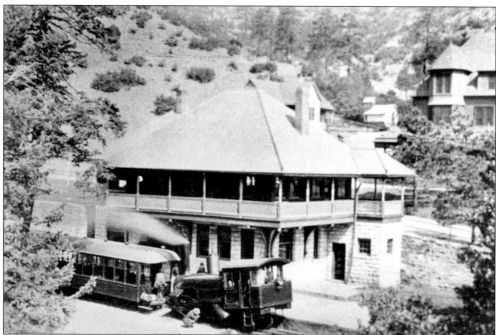

To accommodate the large number of expected passengers, the management of the M&PP built this handsome depot on Ruxton Avenue. Great care was placed in the location of the depot as it was right across the street from the Iron Spring Hotel and Casino and just west of the Ruxton and Grandview Hotels. (Photo by W.E. Hook.)

While a good deal of money was invested in the construction of the M&PP depot, the locomotive shops and outbuildings were simple structures. Shown here just west of the depot are railroad engine and maintenance facilities. Plain but functional, these buildings served the railroad for many years. (Photo by Horace Poley.)

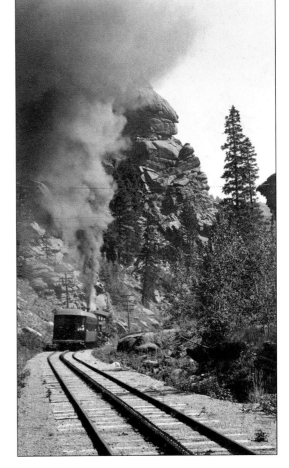

On most railroads, locomotives were coupled to the front of the train and pulled coaches. However, the Manitou & Pike's Peak was different and so was its method of transporting passengers. This photo, taken soon after a M&PP train left the Manitou Depot, illustrates how the cog engines would push a coach upgrade toward the summit.

To Pike's Peak
by Rail. . . .

Manitou
And
Pike's Peak
Railway

MAKES THE ROUND TRIP IN
FOUR AND ONE HALF HOURS.

The Highest and Most Wonderful Railway
in the World.
Trains leave Manitou at Convenient Hours
during the Season.
See Time Table.

For TICKETS and PARTICULARS
ENQUIRE AT PRINCIPAL RAILROAD TICKET OFFICES.

This 1892 ad shows the M&PP's new logo. The railroad incorporated the unique cog gearing of its locomotives into a unique motif that survives to this day. Also advertised is the four-and-a-half-hour roundtrip to the summit of Pike's Peak. This was less than half the time it took ride on burro.

The high altitudes, cold temperatures, and changing weather patterns along the right-of-way of the M&PP often treated tourists to snow well into spring and sometimes the summer. In this photo, some passengers have paused for a snowball fight. The ties in the background were part of an annual maintenance program and were deposited at various locations along the line. These were usually brought up from Manitou on one of the M&PP's two flat cars.

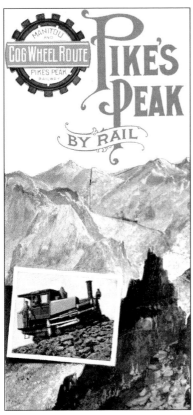

Mass-produced and displayed in the timetable racks of local railroad depots, this 1896 brochure informed arriving passengers of all the sights offered by the Manitou & Pike's Peak Railway. Inside the eight panels were loaded with the history of Pike's Peak and what visitors could expect to find while riding the cog railroad. Also listed are the elevations and mileage of various points along the route and directions to get to the M&PP depot.

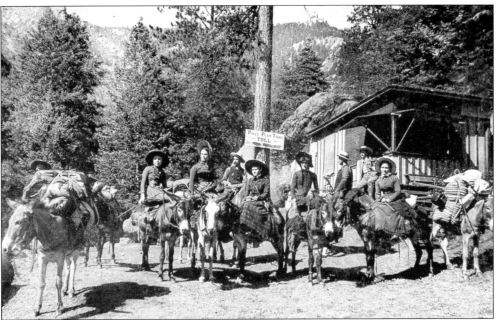

Burros remained a popular way of getting around Manitou and Pike's Peak even after the railroad was built. A day trip usually cost about $2.50 per person and could be arranged for trips up the mountain, or to a number of other local destinations.

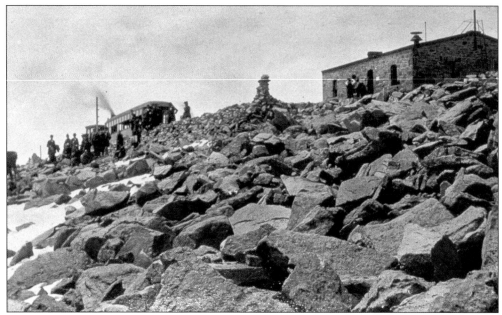

By 1891 the old U.S. Army Signal Corps station on top of Pike's Peak was being used as a depot for the Manitou & Pike's Peak Railway. Called Summit House, the structure would later be expanded to host the large number of seasonal visitors. The first trainload of passengers reached Summit House on June 30, 1891. (Photo by W.E. Hook.)

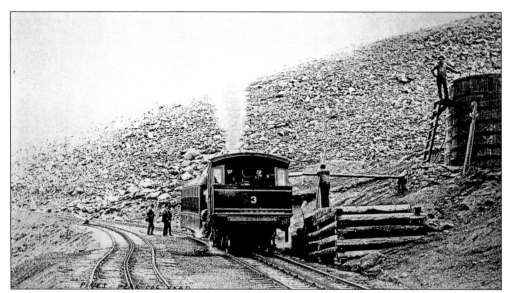

At 12,233 feet above sea level, according to an 1890s measurement, Windy Point was well named. Its barren rocky landscape was one of the few points above timberline where the M&PP's engines could take on water. At the time of its construction, Windy Point was reported to be the highest railroad water tank in the world. In this photo, an uphill-bound Engine No. 3 pauses at Windy Point for a drink. The siding on the left enabled trains bound for Manitou to make the downhill journey without delay. (Photo by W.E. Hook.)

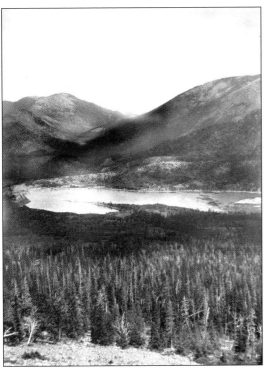

One of the most scenic points along the line of the Manitou & Pike's Peak Railway was along "Big Hill. " Here the 25 percent grade justified why the M&PP's engines were powered by gears and cogs, and not the rods of conventional engines. This location also afforded passengers a wonderful view of the distant Lake Moraine.

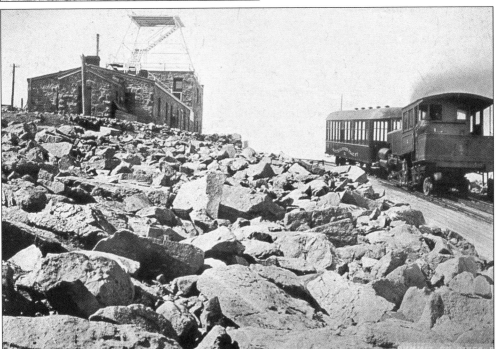

This image shows Engine No. 1 arriving at the top of Pike's Peak. As if 14,000-foot Summit House was not enough for the mountain visitor, an observation platform was built to afford passengers a 360-degree view of Colorado. In 1893, the wonder of Pike's Peak inspired Katherine Lee Bates to write "America the Beautiful."

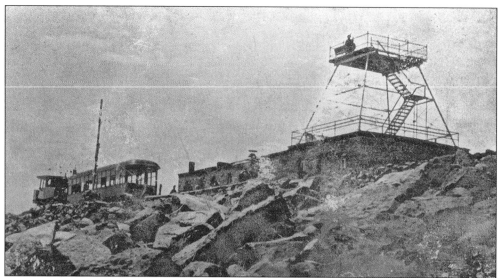

Allowing plenty of time at the top of Pike's Peak for passengers to take in the magnificent view, the railroad soon realized it had a captive audience. The Summit House was expanded and a lunchroom offered passengers meals and drinks while a gift shop sold trinkets like this pressed-tin souvenir ashtray.

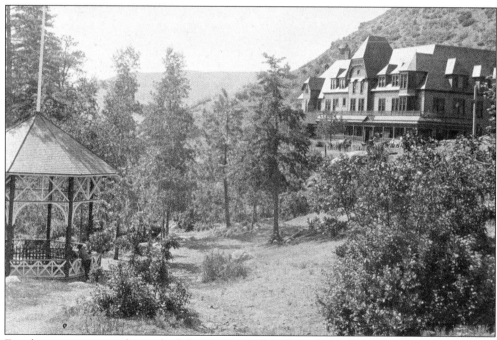

For those passengers who wished for more comfort than the cabins of Ruxton Park or the Halfway House could provide, the nearby Iron Springs Hotel afforded modern conveniences in a rustic setting. This view shows the second Iron Springs Hotel that was built across from the M&PP depot on the north side of Ruxton Avenue. (Photo by W.E. Hook.)

Eight

Colorado Springs Rapid Transit

As the towns of Colorado Springs, Colorado City, and Manitou grew, so too did the distances that residents and tourists had to travel in the completion of their business or to see all of the local attractions. In 1887, the need for adequate and scheduled public transportation was championed by a group of local businessmen who built the Colorado Springs & Manitou Street Railway. These horse-drawn trolleys were soon electrified and in the early 1890s, the newly formed Colorado Springs Rapid Transit Railway had trolley lines to Colorado City and Manitou, the Tejon Street Business District, and to the outlying areas of Roswell, Austin Bluffs, the Broadmoor, and the Union Printer's home. The CSRT initiated a public transportation system that the Pike's Peak Region would enjoy for many years.

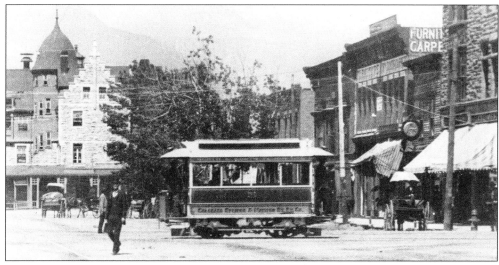

This early 1890s view shows the heart of the Colorado Springs business district and the corner of Tejon Street and Pike's Peak Avenue. In the distance is the Antlers Hotel. The trolley in the photo is Colorado Springs & Manitou Street Railway No. 5 on the Tejon Street Line. No. 5 was probably one of the original horse cars that had initially started service in the late 1880s and was soon converted to electricity. (Photo by W.H. Jackson photo.)

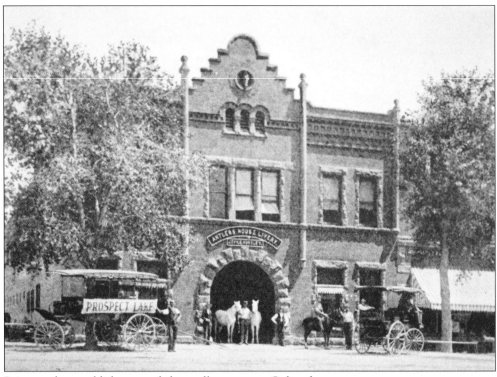

Prior to the establishment of the trolley system, Colorado Springs visitors and residents had to rely on horse-drawn carriages. This photo shows the Antlers Livery, whose stables provided transportation for hotel guests and offered wagons and horses for rent. One of the carriages in this photo, dedicated for "city service," is destined for Prospect Lake. The trolley line out to Evergreen Cemetery and the Union Printer's home would replace the need for carriages like these.

During the early 1890s Andrew Lawton became one of the Colorado Springs Rapid Transit Railway's major stockholders and decision makers. Prior to this, Lawton had done a lot of speculating in Colorado Springs real estate and was partially responsible for the development of the town of Roswell. Lawton envisioned a street railway system that connected the business center of Colorado Springs and Manitou with new residential communities like Roswell, Austin Bluffs, Nob Hill, and the Broadmoor.

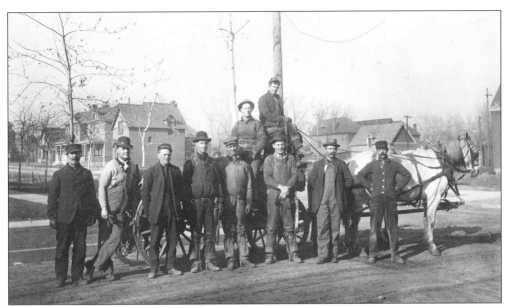

The departure from horse cars to electric trolleys required many upgrades to the existing lines of the Colorado Springs & Manitou Street Railway. Right-of-way improvements and heavier rail were needed along with installation of many miles of trolley wire and hundreds of poles. The pole crew in this picture pauses along North Tejon Street while replacing some poles on the Roswell line.

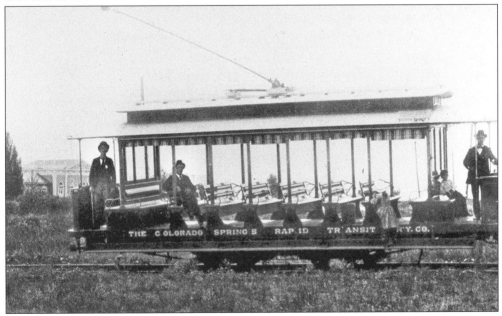

One of the more frequented routes of the early CSRT was the Broadmoor Line. A Silesian nobleman named James Portales had turned the old Broadmoor Dairy Farm into a playground for the rich. Featuring a casino, lake, dance pavilion, and picnic grounds, the Broadmoor became a very popular attraction, and the trolley became the ideal way to shuttle people back and forth. This photo shows one of the CSRT's summer cars parked in front of the Broadmoor Casino.

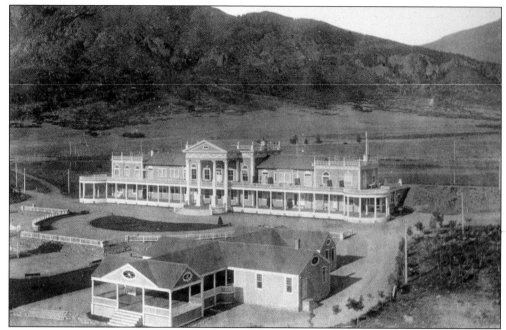

Shown here, the Broadmoor Casino was very popular with trolley-goers. Weekend concerts, picnics, and golf outings were heavily advertised in Colorado Springs and usually well attended. At one time, the Broadmoor line was headed south from Colorado Springs over Nevada Avenue but later was reached from South Tejon Street via Cheyenne Boulevard, Seventh Street, and Lake Avenue. The trolley tracks loop and station were on the north shore of Cheyenne Lake on the extreme right of the picture. (Photo by W.E. Hook.)

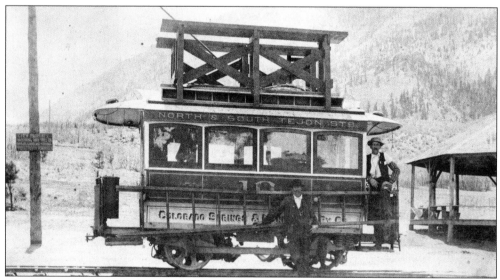

This early view shows Colorado Springs & Mantiou Street Railway Car No. 10 on a portion of track near the Broadmoor. Car No. 10 was probably one of the original horse cars and was later used for maintenance after its conversion to electricity. The scaffolding on the roof allowed workers to hang and repair wire.

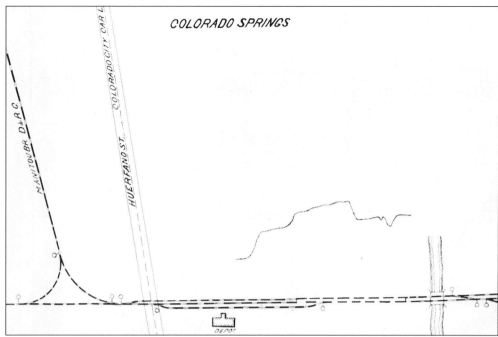

One of the main routes of the CSRT was the line west from Colorado Springs through Colorado City and the Manitou Line. To make this connection, tracks were laid west along Huerfano Street, followed Colorado Avenue through Colorado City, and then Manitou Avenue in Manitou. When the tracks were initially built, the greatest barrier to trolleys were the tracks of the D&RG. In 1892, the Huerfano Street Viaduct elevated the trolleys over the railroad tracks. This linen map, which dates to about 1890, shows the D&RG's depot, the Manitou Branch, and the grade crossing of the CSRT.

By the mid-1890s when this advertisement was printed, the Colorado Springs Rapid Transit Railway had 22 miles of track and served many local attractions. Besides providing service to all of the major hotels and railroad depots in Colorado Springs, trolley tracks ran to Austin Bluffs, the horse track at Roswell and the new Union printer's home east of the Santa Fe depot.

This early coat badge from the Colorado Springs Rapid Transit Railway dates to the 1890s. Coat badges usually had white backgrounds with black lettering while hat badges had black backgrounds with white lettering.

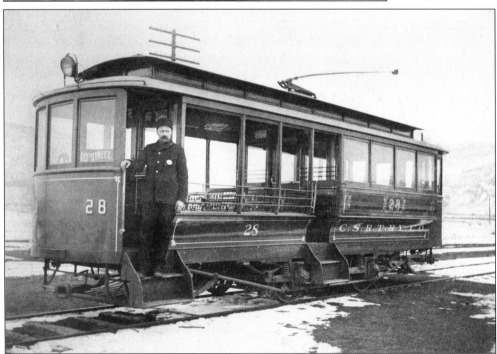

CSRT No. 28 was built by the Denver-based Woebber Car and Carriage Company in 1898. Having both an open and closed section, this car was ideal for the rapidly changing weather conditions of the Pike's Peak Region. In this late 1890s photo, No. 28 was traveling west of Tenth Street on the Broadmoor Line. The motorman is wearing a coat badge similar to the one in the above photo.

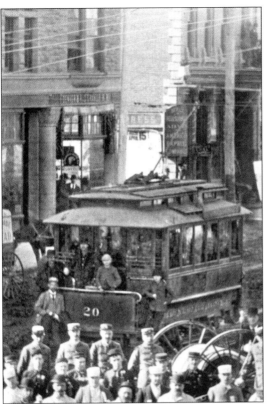

Parades were very common in Colorado Springs. This scene shows a group of fireman followed by CSRT No. 20 near the corner of Tejon and Pike's Peak Avenue. In the background are the offices of several express companies and the Denver & Rio Grande city ticket office.

CSRT car No. 28 could usually be found all over the Tejon Street Line from Broadmoor to Roswell. This photo was taken in the CSRT's Tejon Street Carbarn. The line to Roswell was routed around Colorado College, past the turning wye at Harrison Street, over the Rock Island tracks, and around the Roswell Loop near the racetrack.

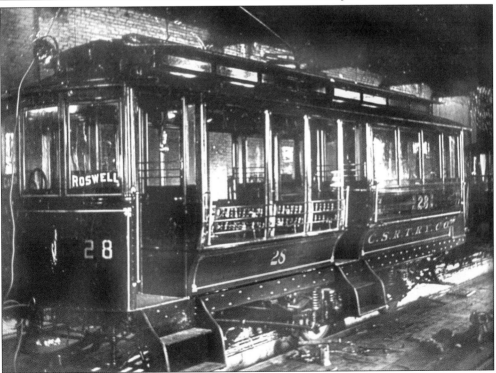

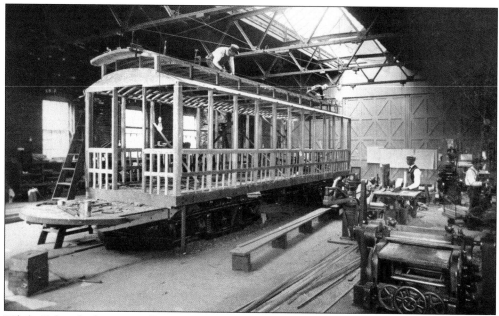

While Colorado Springs trolley cars were stored in the Tejon Street Carbarn, there was also a large shop area nearby on South Cascade between Moreno and Cimarron. During the early 1890s, it was common for the CSRT to purchase their cars. As this photo shows however, as time progressed, the company began to build its own equipment.

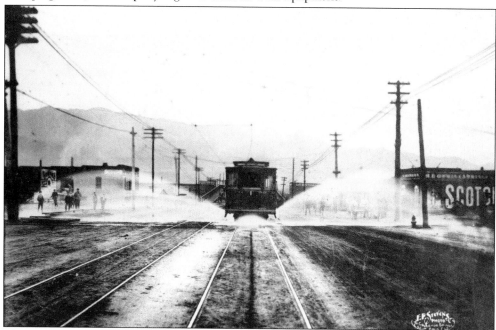

The tracks of the CSRT were built over streets that were still dirt. Part of the agreement between the City of Colorado Springs and the trolley line required the CSRT to take responsibility for keeping the dust down on busy thoroughfares. This was accomplished through the use of sprinkler cars. In this photo, Sprinkler No. 1 has just crossed over the Huerfano Street Viaduct and is traveling east. (Photo by F.P. Stevens.)

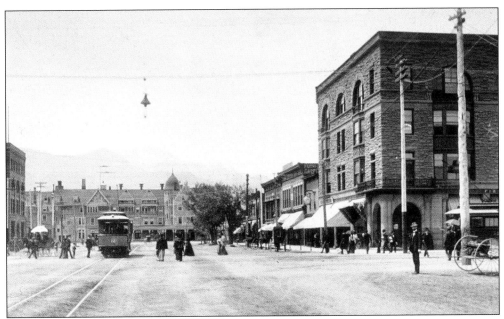

One of the busiest intersections in Colorado Springs is shown here in the photograph of Tejon and Pike's Peak Avenue. Car No. 12 is heading east towards the Santa Fe depot while on the right side of the view, one of the 30-series cars travels south on Tejon Street.

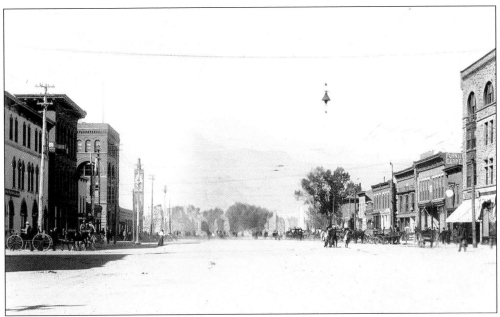

The skyline of Colorado Springs was dramatically changed after the Antlers Hotel fire in 1898. The absence of the guests during the rebuilding of the hotel no doubt hurt the fare boxes of the CSRT, but it is probable that the trolley line played an active part in the helping to clear the debris from the old hotel and assist in brining in materials for the new one.

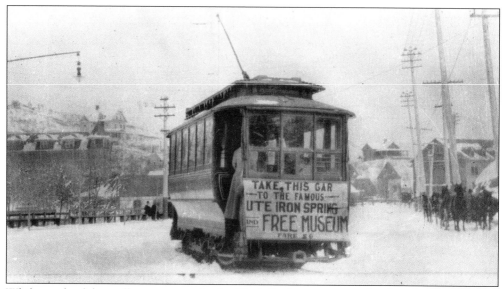

While much of the trolley patronage in the Pike's Peak area was confined to the routes in and around Colorado Springs, there was also a trolley line between Manitou and the Cog Railway Depot. The Manitou Electric Railway and Casino Company was formed in the early 1890s to connect the town of Manitou with the depot of the Manitou & Pike's Peak Railway. Trolleys ran in all sorts of weather and this winter scene shows one of the Ruxton Avenue cars on the Manitou Circuit.

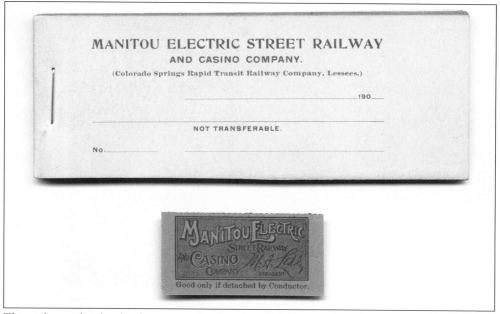

This ticket and ticket book are two of only a handful of reminders that mark the existence of the Manitou Electric Railway and Casino Company. Local Manitou hotels that offered tourist packages with the Manitou & Pike's Peak Railway would include trolley tickets as part of the package. Many of the locals who attended dances at the Iron Springs Hotel came out from Colorado Springs on the larger two truck cars and transferred to the "Dinkey" at Manitou.

Nine

EXCURSION TO PALMER LAKE

During the halcyon years of Colorado railroading, few places along the foothills of the Pike's Peak Region could match the inherent beauty of Palmer Lake. Initially just a water stop on the D&RG, the railroad facilities here were first called Summit. Other names followed including Summit Lake, Divide, Loch Katrine, Weissport, Palmero, and finally Palmer Lake. Both railroad companies and passengers were quick to notice the area's appeal and potential. By the mid-1880s, the D&RG had built a small ornate depot and dock for boating. An eating house and dance pavilion soon followed along with well-groomed nature trails and picnic areas. In 1887 the Santa Fe arrived, and the lake and budding community were now served by two railroads. Throughout the 1890s, the popularity of Palmer Lake continued to grow, as did the development of the town and the cottage city of nearby Glen Park. During the summer months, so many people from Colorado Springs flocked to Palmer Lake that local organizations often chartered excursion trains.

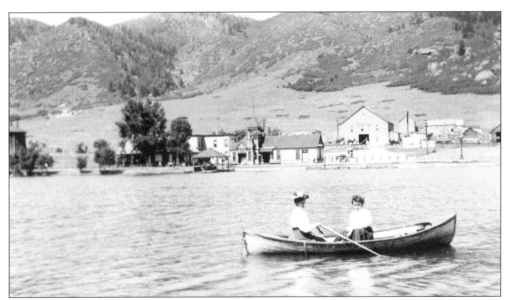

Boating on Palmer Lake was a very popular pastime, and rowboats were kept at the D&RG boat house for rent. This photograph, taken from the east shore, looks west across the lake towards the D&RG tracks and facilities. In the distance are the D&RG depot, eating house, water tank, boathouse, and the livery stable of Thomas Hanks.

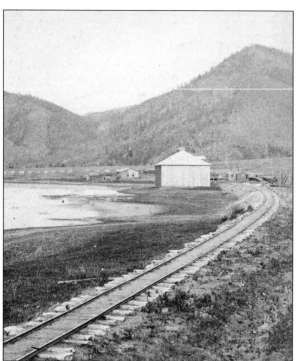

This 1870s view of the D&RG's narrow-gauge railroad facilities at Palmer Lake is one of the earliest known photographs of the area. Then called Divide and on some timetables Summit Lake, this image looks southward at a rustic section house and ice house. (Photo by James Thurlow.)

By the mid-1880s the rough-hewn railroad buildings of a decade before had given way to this small, ornate depot. Built with a waiting room, baggage area, and a gingerbread cupola, this station was manned by an agent who handled both ticket sales and telegraph duties. The baggage area to the right was later expanded to handle the additional traffic of hotel and Chautauqua guests, and provide winter storage for the rowboats. (Photo by Horace Poley.)

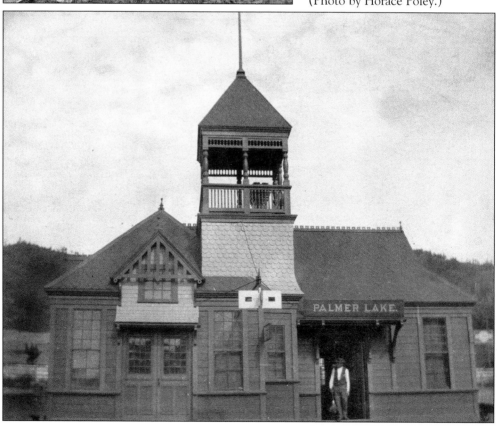

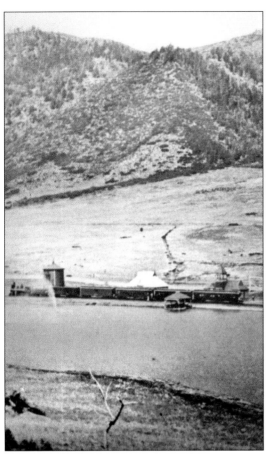

Photographer William Henry Jackson worked hard to get this early photograph. The image looks to the west from the heights of Ben Lomond Mountain across Palmer Lake to the tracks of the D&RG. The southbound train has paused to take on water and give passengers a chance to get a quick meal at the recently built Judd Eating House. The Eating House Annex, built to house employees and a few boarders, does not appear next to the Judd lunch room, suggesting that this image may have been taken around 1885. (Photo by William H. Jackson.)

The standard-gauged third rail, which was added to the D&RG tracks in the early 1880s, is plainly visible in this 1890s view. In the foreground is the boathouse and fishing pier that were both built by the Denver & Rio Grande in the mid-1880s. Across the lake is the Santa Fe's stone depot. The D&RG was so incensed with its competitor's arrival in Palmer Lake that it briefly entertained the idea of building a tall wooden fence along the east shore of the lake to deprive Santa Fe passengers of the beautiful view. (Photo by Horace Poley.)

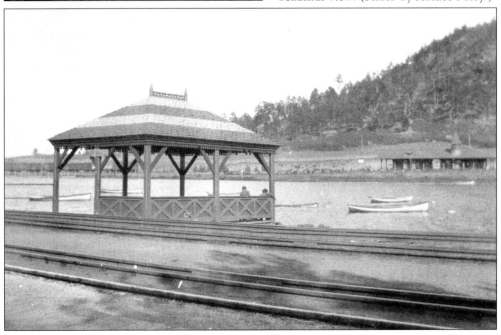

The train order signal of the Palmer Lake depot juts out into this snowbound 1892 scene. Palmer Lake was located on the highpoint of the D&RG's mainline between Denver and Pueblo. Its altitude and geography made the Palmer Divide area prone to heavy snows. This photo looks north at a southbound D&RG engine trying to make its way past the depot. (Photo by Horace Poley.)

During the summer months, the area around the D&RG's Palmer Lake depot was often a scene of great activity. Around the depot grounds, boaters and picnickers, combined with hungry lunchroom customers and waiting passengers, packed the lake's west shore. This 1890s scene is indicative of "train time" at the depot. (Photo by Horace Poley.)

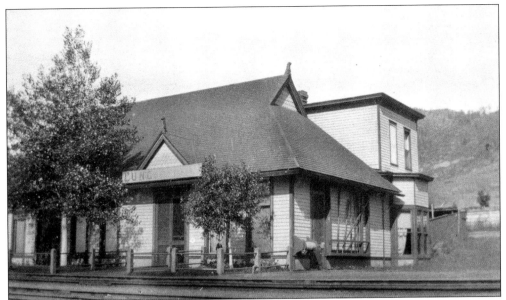

To complement the new Palmer Lake depot, plans were made to build a nearby restaurant. By 1885, John L. Judd had made arrangements to lease property from the D&RG and soon erected the very popular Judd Eating House. This 1890s photo shows the eating house as well as the annex built on the west side. The annex increased the size of the dining area and also provided room for employees. (Photo by Horace Poley.)

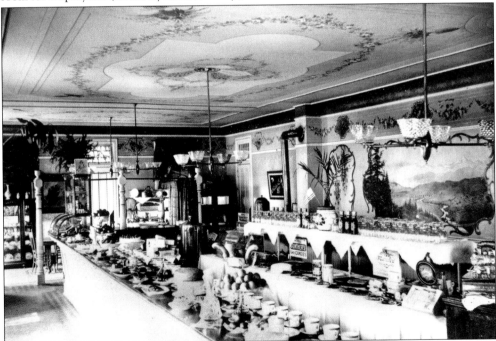

Complete with stained-glass windows and floral designs on the ceiling, the interior of the Judd Eating House was tastefully decorated and stocked with all kinds of candies and snacks. The lunch counter is crowded with coffee cups, pies, cakes, and fresh fruits, all waiting for the next train load of D&RG passengers. (Photo by Horace Poley.)

=PALMER LAKE LUNCH ROOM!=

On the line of DENVER & RIO GRANDE, MISSOURI PACIFIC, and
ROCK ISLAND Railroads.

John L. Judd, Prop., - Palmer Lake, Colorado.

All Passenger Trains Stop Here For Lunch!

LUNCHES FOR PICNICS, PAVILION FOR DANCING,
BOATS FOR ROWING OR SAILING ON THE
MOST BEAUTIFUL SHEET OF WA-
TER IN COLORADO.

PALMER LAKE is pre-eminently one of the GEMS OF THE MOUNTAINS, and, together with its many rocky glens, presents one of the most beautiful and picturesque grounds for picnics or other parties in the State.

The mention of the Rock Island as one of the railroads serving Palmer Lake dates this advertisement to about 1890. With over a dozen trains a day, John Judd had plenty of customers, and the dances and picnics held on the weekends attracted even more visitors.

Rio Grande Hotel Company

Denver & Rio Grande R.R. — Scenic Line of the World

1897 No. 67

Mr. *E. E. Nichols & Family*

PASS FOR MEALS AT ALL HOUSES OPERATED BY THIS COMPANY.

E. G. Thayer

Similar to those issued by Fred Harvey, the D&RG also issued passes that were good for discounted meals at their hotels and eating houses. Since Judd leased the land from the D&RG but owned the eating house, his relationship with the Rio Grande Hotel Company was a loose affiliation. This pass was issued to E.E. Nichols, a prominent Manitou hotel operator. (Courtesy of Bill and Sue Knous.)

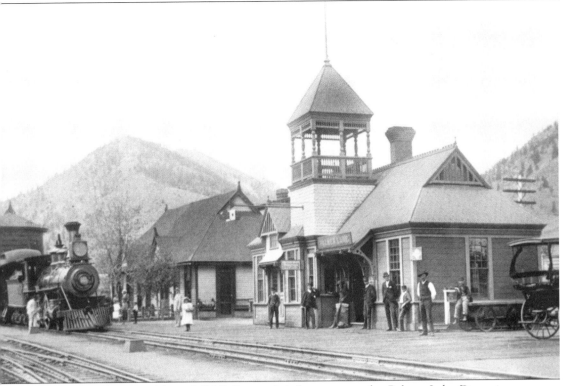

In this photograph, a northbound D&RG train briefly pauses at the Palmer Lake Depot in the mid-1890s. The length of the stop at Palmer Lake varied from 10 to 15 minutes, depending on whether the train had to take on water and if the train was an express or a local. This stop gave passengers enough time to stretch their legs and visit the eating house. (Photo by Horace Poley.)

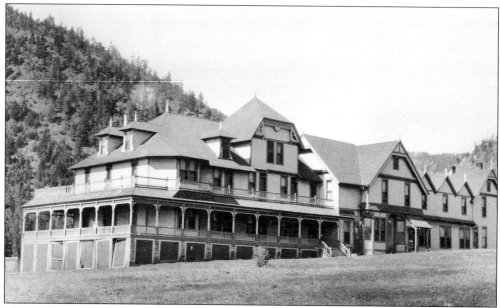

The photograph shows the Rockland Hotel, which was located a short walk to the west of the D&RG depot. At first the hotel was referred to as the Glen House and opened in June 1884. Well patronized, the hotel was expanded by Dr. William Finley Thompson and by 1890 was called the Rockland. Billed as both a hotel and a sanitarium, the hotel was remodeled several times and eventually boasted 80 rooms.

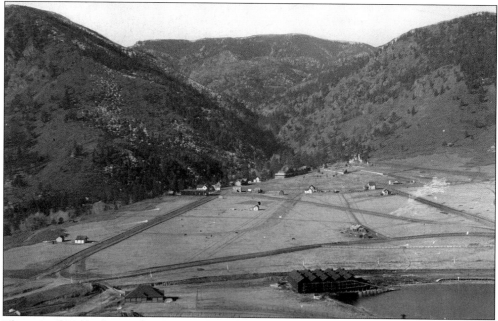

This view from high atop Ben Lomond Mountain looks down on the southern end of Palmer Lake, toward Chautauqua Crest and Sundance Mountain. In the middle of the photograph is the Rockland Hotel and Estemere, the estate of Colorado mining and railroad magnate Eben Smith. Also in the photo is the south icehouse, the two wagon bridges over the D&RG and Santa Fe tracks, and the dance pavilion.

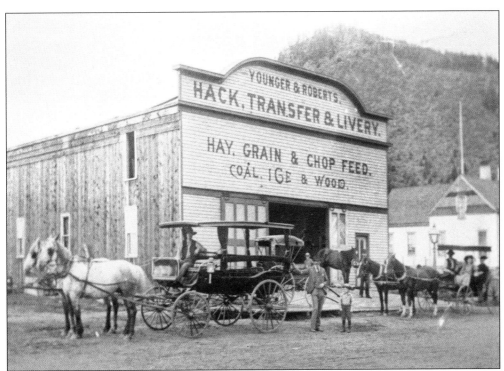

One of the more profitable businesses in Palmer Lake was the Younger & Roberts Livery. Founded by William Younger and Bennie Roberts, the livery provided a hack and express service that picked up D&RG and Santa Fe passengers from their respective depots and ferried them to the Rockland Hotel, Glen Park, and the Chautauqua Grounds. They were also the local fuel dealer and used a siding near the D&RG's turntable to store coal. (Photo by Horace Poley.)

As areas like the cottage city at Glen Park and the Rockland Hotel developed, the area to the south and west of Palmer Lake became a haven for nature lovers. This scene shows one of the rustic bridges that connected the nature trails of Glen Park.

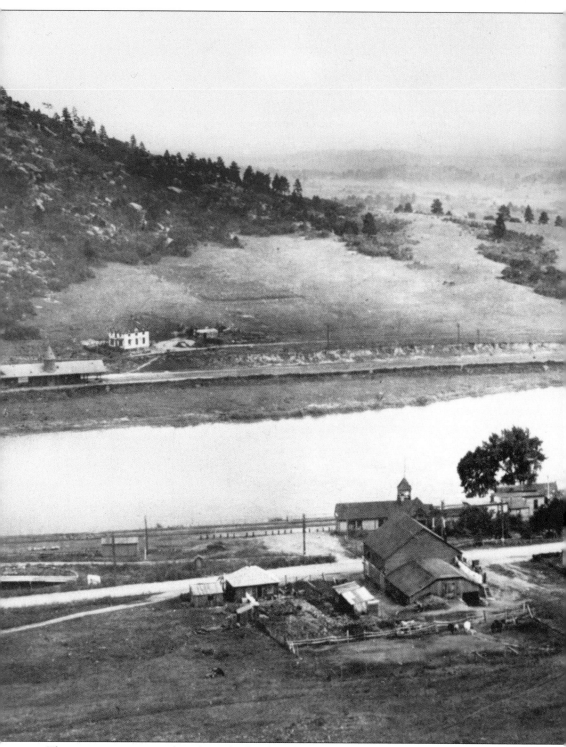

This panoramic view, taken from the heights above the Ben Lomond Ranch, looks southeast across Palmer Lake toward the town of Monument. In the distance, a northbound Santa Fe

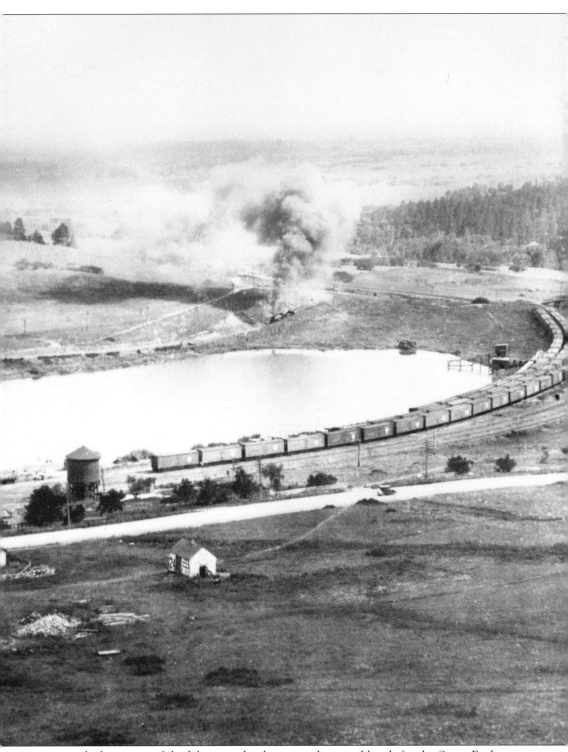

train rounds the corner of the lake near the dance pavilion, and heads for the Santa Fe depot.

This turn-of-the-century view looks across Palmer Lake to the Santa Fe depot on the east shore. Above the depot is Ben Lomond Mountain, which provided a scenic backdrop for early photographers. By 1900 the popularity of Palmer Lake saw the use of advertising billboards like the Schlitz Beer sign on the hill north of the station. (Courtesy of P.R. "Bob" Griswold.)

A freight train has stopped at Palmer Lake, as evidenced by the engine smoke and caboose in the extreme right of this photograph. In the distance are the south icehouse, dance pavilion, and the wagon road bridge over the Santa Fe tracks. (Photo by Horace Poley.)

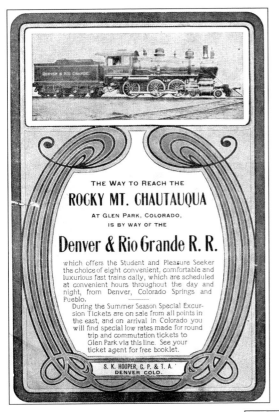

As the Methodist Chautauqua movement spread from New York to the West, Palmer Lake was selected as the gathering place for the Rocky Mountain Chautauqua. The summer-long social and religious retreat was hosted in Glen Park beginning in 1887. It was so successful that the meetings became a perennial event. Knowing that hundreds of clergymen, lay people, and teachers would attend, the D&RG printed large advertisements like this in the hopes of attracting additional revenue.

The D&RG water tank at Palmer Lake sat just south of the Judd Eating House. There were initial fears that the tank would drain the water level of the lake but the problem was solved by a gravity feed from nearby reservoirs. (Photo by Horace Poley.)

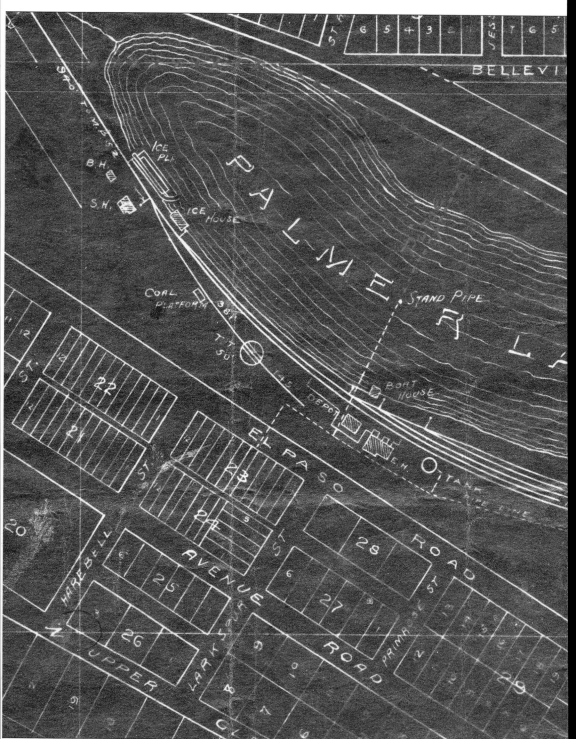

This 1890s map shows all of the major D&RG facilities at Palmer Lake. The left side of the map shows the north ice house along with the D&RG's bunk house and section house. To the south are the coal bunker and a 50-foot turntable used to turn helper engines. On the east shore of

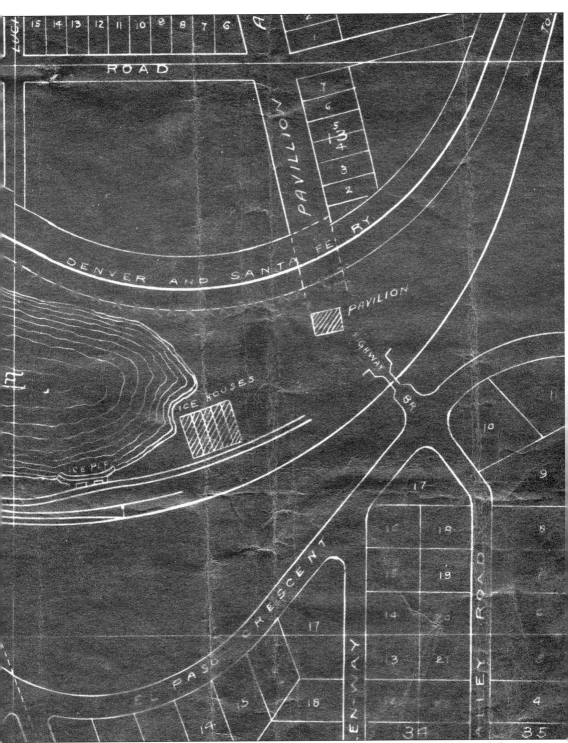

the lake is the depot, eating house, and boathouse, while the south icehouse, dock, and the dance pavilion are located on the south shore.

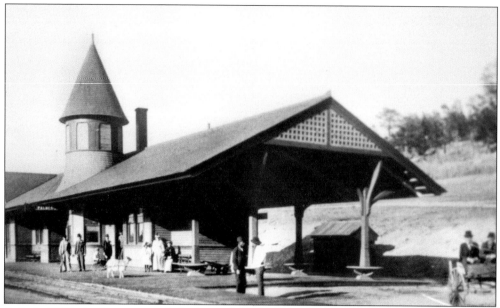

Built in 1887, the long, covered platform of the Santa Fe's Palmer Lake depot served as a roof for both the passenger and freight office. In this 1890s photo, the station agent looks on behind a boy riding a goat cart. The Santa Fe had a lunch counter in its depot but despite the fine dishes prepared by chef William Fonash, it was always overshadowed by the Judd Eating House. (Photo by Horace Poley.)

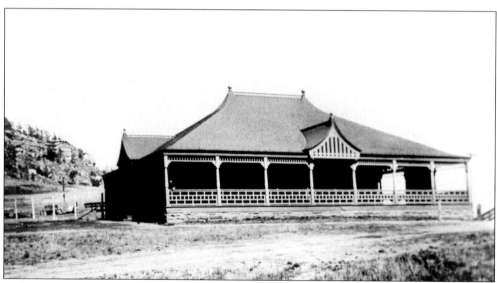

Higher in elevation than Colorado Springs, Palmer Lake became a cooler alternative for many nature lovers looking to enjoy summer outings. During the 1890s, the dance pavilion was a popular place where local musicians like the D&RG's Burnham Shops Band entertained crowds with rags, stomps, and fox trots. (Photo by Horace Poley.)

Ten

RAILROADS OF EARLY CRIPPLE CREEK

Until the late 1880s, much of the growth and development of the railroads and communities in the Pike's Peak Region were limited to the plains around Fountain and Monument Creeks. However, the discovery of gold in the Cripple Creek District prompted the settlement of the mountains and valleys to the west of Pike's Peak. By 1892, news of Bob Womack's gold discovery in Poverty Gulch had spread throughout the state. Over the next few years, these once barren pastures gave way to the towns of Cripple Creek, Victor, Altman, Independence, Goldfield, and Gillett. A railroad was needed to economically transport the ore to reduction mills, and in 1894, the Florence & Cripple Creek Railroad completed its narrow-gauge tracks to Cripple Creek. A year later the standard-gauge Midland Terminal Railway built south to Cripple Creek from a connection with the Colorado Midland at Divide. Together, these two railroads ushered in a new age of prosperity for the Cripple Creek District and played an important role in its early success.

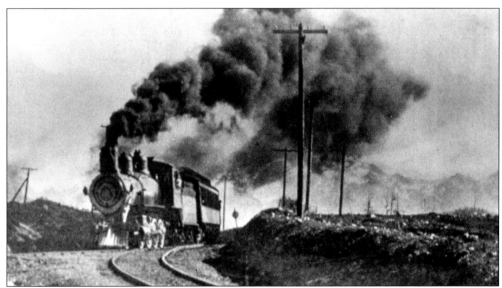

Due to an early financial struggle, the Midland Terminal Railway did not reach Cripple Creek until several years after the discovery of gold. Despite its late arrival, the large capacity of its standard-gauge cars and equipment had an immediate impact on traffic in and out of the district. This 1890s photo shows a Midland Terminal passenger train coming through Gillett on its way to Victor and Cripple Creek.

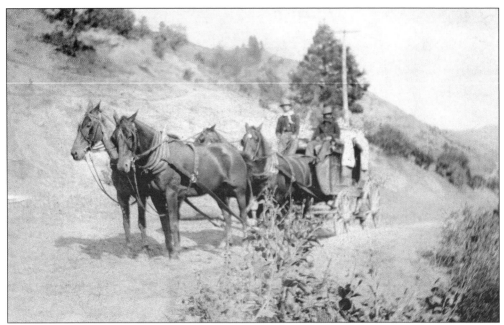

From 1891 until the first part of 1894, ore shipments from the mines around Cripple Creek were transported to reduction mills using ore wagon like these. The wagons had a limited capacity and freighters charged exorbitant rates so only the highest valued ore could be shipped. Most ore wagons traveled on the wagon roads leading north from Cripple Creek to Florissant and Divide. Here the ore was transferred to the Colorado Midland Railway.

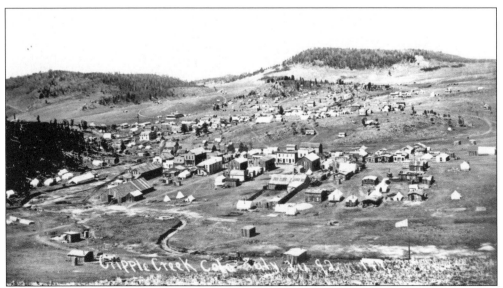

This is how Cripple Creek appeared in July 1892. Truly a boomtown, most of the buildings in this photo were erected in just a few short months. Cripple Creek was initially made up of two communities, Hayden Place (in the foreground) and Fremont to the west. The two towns were soon combined and through the 1890s Cripple Creek continued to grow as its own incorporated entity. (Photo by William J. Gillen.)

118

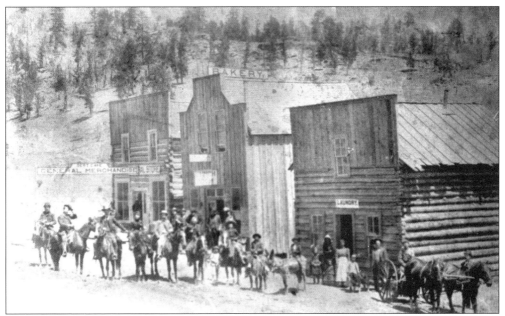

A few miles southeast of Cripple Creek was the "town" of Lawrence. Originally part of the south pasture of the Victor Adams Ranch, in 1893 Lawrence consisted of a few rustic buildings including a laundry, a bakery and boarding house, and Bert Cave's General Store. It was also home for the Lawrence Gold Extraction Company, an early reduction mill. By 1896, much of Lawrence had been absorbed into the town of Victor. (Photo by Horace Poley.)

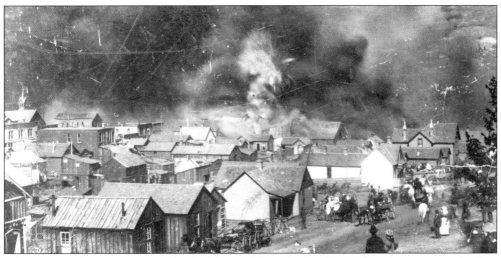

Like many early mining towns, the buildings of Cripple Creek were hastily constructed, often of green wood. On April 29, 1896, a fire broke out in Cripple Creek with disastrous results. In this photograph, the residents of Meyers Avenue look east toward the spreading conflagration. Smoke pours from the livery barn in the center of the image, where firemen vainly tried to fight back the flames. Eventually dynamite was used to create a firebreak but the charges were excessive and the resulting explosion only spread the flames. This was the second fire to hit Cripple Creek in a week and between the two, most of the business district was destroyed. (Photo by Edgar A. Yelton.)

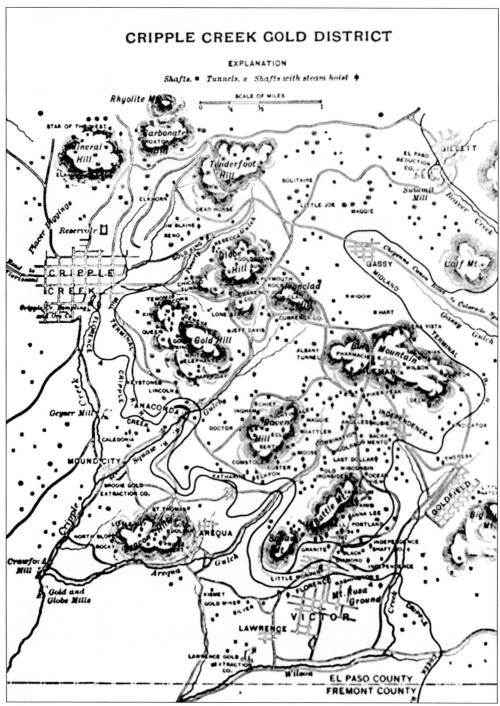

This 1890s map illustrates the geographic layout of the Cripple Creek District along with the towns, major mines, and the routes of the Florence & Cripple Creek and Midland Terminal. Shown on the map between Battle Mountain and town of Victor are two of the district's most profitable mines, the Portland and the Independence.

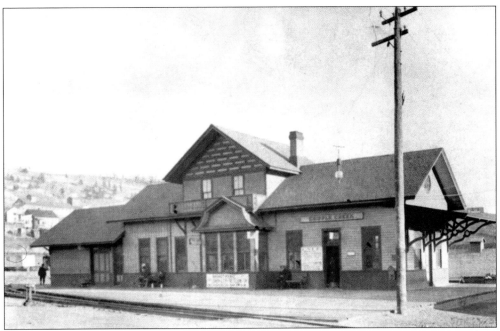

Formal passenger service over the completed line of the Florence & Cripple Creek Railway began on July 1, 1894. Soon after arriving in Cripple Creek, the F&CC built this depot near Xenia Street. The depot and the nearby freight house were close to the business district and F&CC passengers only had to walk a block north to the trolley barn and interurban connections throughout the district.

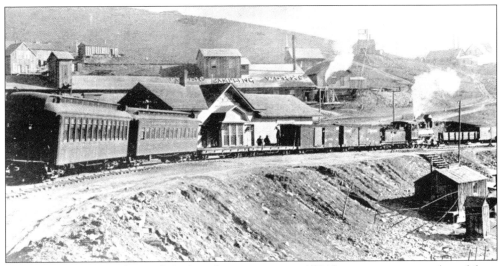

The Florence & Cripple Creek Railway began service in 1894 by using equipment leased from the D&RG. The D&RG had recently converted some of its tracks to standard-gauge leaving a large surplus of narrow-gauge motive power. The F&CC was able to lease locomotives, freight and passenger cars at very reasonable rates, thereby defraying operating costs until it had generated enough revenue to buy its own equipment. This 1895 photo shows an F&CC mixed train made up of a D&RG locomotive and cars in front of the Victor depot. (Photo by A.J. Harlan.)

Florence and Cripple Creek Railway

East	Depart	(RIO GRANDE)	West	Arrive	
No. 6 Pullman Daily	No. 10 C.C. Ex. Daily	Effective Dec. 9, 1894	No. 1 Denver Ex Daily	No. 5 Pullman Daily	
7: 15 a m	5: 00 p mDenver.......................	8:30 a m	7: 45 p m	
4: 07 a m	2: 30 pmColorado Springs..............	11: 20 a m	10: 50 p m	
2: 30 a m	12:50 p mPueblo....................	12: 50 p m	12: 20 a m	
12 30 a m	11: 40 p mFlorence....................	1: 48 pm	3: 30 a m	
12: 20 a m	11: 27 pmCyanide...................	2: 08 p m	3: 38 a m	
12: 19 a m	11: 26 a mVesta Junction..............	2: 09 p m	3: 39 a m	
12: 05 a m	11: 16 a mRussell....................	2: 25 p m	3: 56 a m	
11: 40 p m	10: 52 a mMcCourt...................	2: 46 p m	4: 21 a m	
11: 17 p m	10: 32 a mAdelaide...................	3: 05 p m	4: 46 a m	
10: 50 p m	10: 08 a mGlenbrook..................	3: 33 p m	5: 16 a m	
10: 34 p m	9: 55 a mWilbur....................	3: 50 p m	5: 40 a m	
10: 05 p m	9: 30 a mAlta Vista.................	4: 20 p m	6: 15 a m	
9: 50 p m	9: 15 a mVictor....................	4: 35 p m	6: 30 a m	
9: 38 p m	9: 02 amElkton....................	4: 46 p m	6: 42 a m	
9: 29 pm	8: 54 a mAnaconda..................	4: 55 p m	6: 50 a m	
9: 20 p m	8:45 a mCripple Creek.............	5: 05 p m	7: 00 a m	

This F&CC public timetable shows the passenger schedules effective December 9, 1894. There were four through-trains per day that connected to Pueblo, Colorado Springs, and Denver via the D&RG at Florence. There were also four suburban trains, which provided service between Cripple Creek and Victor.

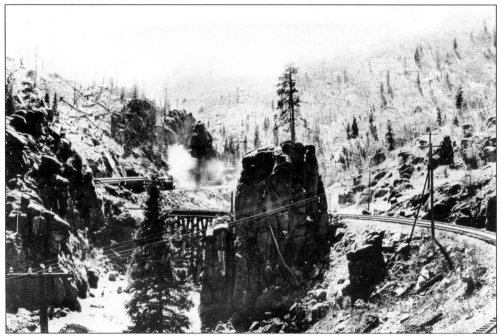

The F&CC's right-of-way through Phantom Canon was some of the finest scenery in Colorado. Prone to flooding, the tracks were repaired and replaced several times during the 1890s. In this photo, F&CC No. 22 pauses near Lone Tree Rock on a "Photographer's Special." (Photo by Weeks.)

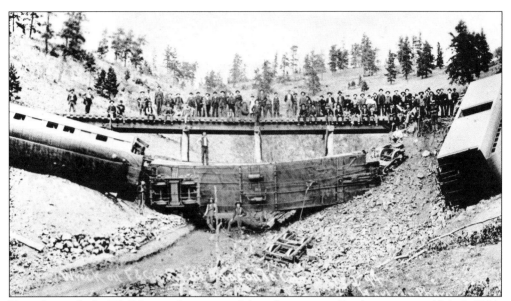

Tragedy struck the F&CC on only its second day of operation. On the morning of July 2, 1894, D&RG Engine No. 39 left Cripple Creek pulling a three-car passenger special. After traveling just a few short miles, the engine rounded a curve near Anaconda and while crossing a trestle, the D&RG coaches derailed. This photo shows the resulting chain reaction with sent both coaches into the dry gulch and the baggage car down an embankment. One passenger was killed instantly and it is probable that another died later from the injuries he received in the wreck. (Photo by A.J. Harlan.)

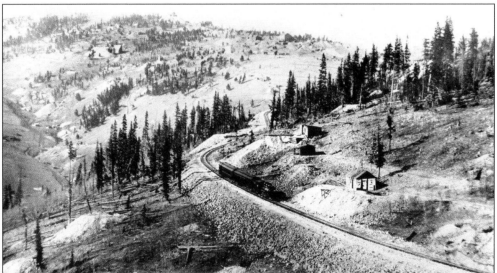

While the F&CC provided a through connection between Cripple Creek and Florence, it also operated suburban trains like the one shown in this photo. The trains usually consisted of a coach and a combine and were often powered by F&CC Engine No. 51. Known as the "Oro," No. 51 was originally delivered from the Schenectady Locomotive Works as a 0-4-4T. A pilot truck was later added changing the configuration to a 2-4-4T. Its tractive effort and ability to negotiate tight curves made the "Oro" ideal for the commuter run between Victor and Vista Grande. (Photo by A.J. Harlan.)

By the late 1890s the F&CC began to consider building a narrow-gauge extension from Victor north through Independence, around Bull Hill, and finishing with a return loop at Vista Grande near Altman. This became the Golden Circle Railroad, a subsidiary of the F &CC and early on, a fairly profitable commuter line. Shown in this photo is Engine No. 52, aptly named the "Vista Grande." This locomotive was a 4-6-0 and built Schenectady in April 1899.

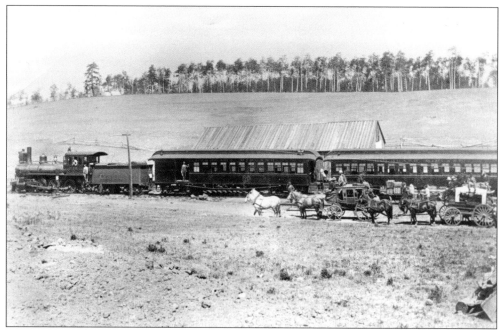

In contrast to the narrow-gauged F&CC, the Midland Terminal Railway was a standard-gauge railroad that got off to a slow start. This photo was taken prior to the construction of the Midland Terminal and shows a Colorado Midland train stopped in Divide. From this point, passengers bound for Cripple Creek were transferred to stagecoaches. Even after the construction of the Midland Terminal began, the stage still provided through service from the end of track into the District.

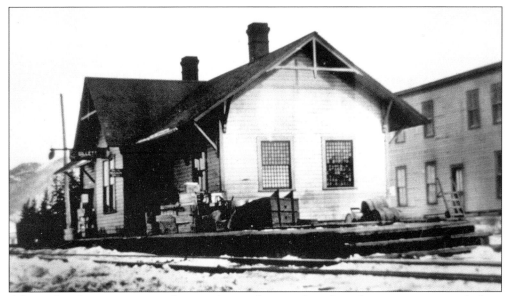

After railroad crews negotiated more than a dozen miles of tough construction south from Divide, the town of Gillett was reached in July 1894. At the same time that the rival F&CC had already reached Cripple Creek, the Midland Terminal was expanding its Gillett facilities and building this depot.

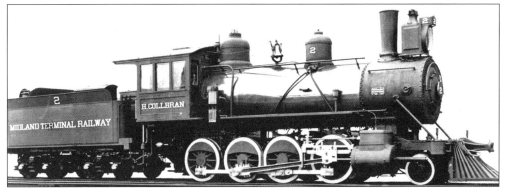

This photo shows Midland Terminal Engine No. 2 at the Schenectady Locomotive Works in 1896. The engine was delivered to the MT as the "H. Collbran." Prior to the construction of the Midland Terminal, Harry Collbran was the general manager of the Colorado Midland. He later became part of the MT's management and was instrumental in completing the line to Cripple Creek.

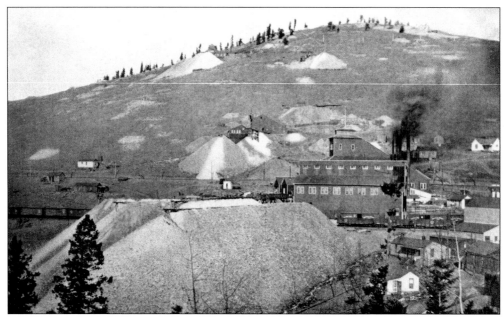

One of the Midland Terminal's best customers was the Elkton Mine. While the mine and the nearby town of Elkton were severed by both the MT and the F&CC, most of the ore was shipped out over the Midland Terminal. In this photo, a long line of Colorado Midland boxcars and gondolas wait on the Elkton siding.

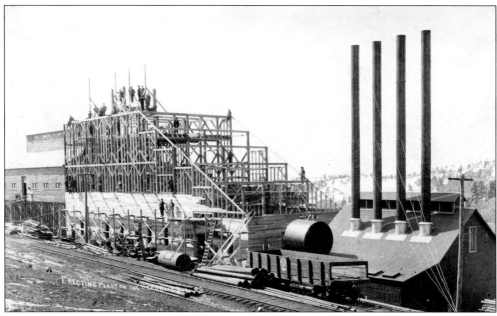

Building a mine or a mill took a great deal of lumber. It also took boilers, pipe, and a lot of special machinery. Many of these supplies had to be brought into the district by the Midland Terminal. This 1899 photo shows the Republic Mine and a load of pipe that was recently unloaded from Colorado Midland gondola No. 1834. (Photo by A.J. Harlan.)

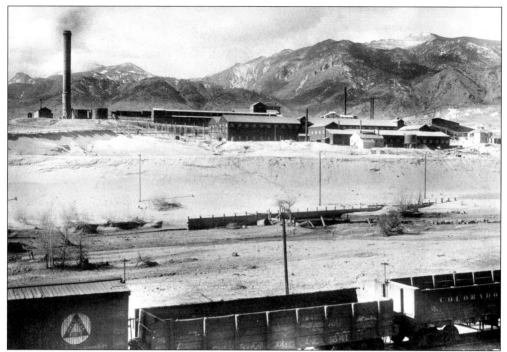

The high output of ore needing to be processed, along with the lack of water and flat land in the Cripple Creek District, prompted the construction of reduction mills like this one in Colorado City. The mills at Colorado City and around Florence played a vital role in the mining process, and provided jobs for hundreds of local workers. (Photo by L.C. McClure.)

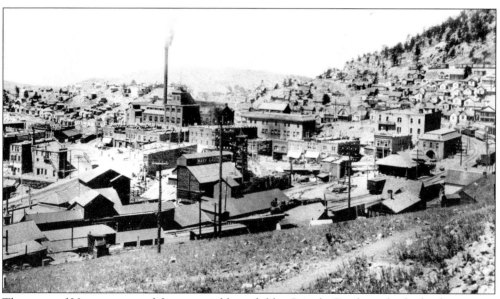

The town of Victor came to life very quickly and, like Cripple Creek, it also had a devastating fire. Named after local rancher Victor C. Adams, the town was surrounded by some of area's most profitable mines. In this photo the Midland Terminal's Victor depot is evident on the right, while in the center is the Gold Coin, Victor's "downtown" mine.

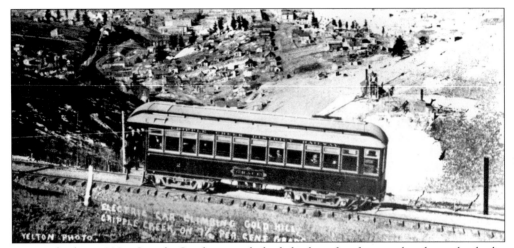

During the late 1890s, Cripple Creek not only had the benefit of two railroads, it also had a trolley system. One of the highest interurban lines in the world, the Cripple Creek District Railway was completed in early 1898 and ran between Cripple Creek and Victor. This photo was taken at the head of Poverty Gulch, faces west, and features CCD trolley No. 2, known as "Grace." (Photo by Edgar A. Yelton.)

Much of the development and the success of the Cripple Creek District were brought about by this man, Winfield Scott Stratton. Stratton was an early arrival to the district and founded the Independence Mine. While often eccentric and reclusive, he was also very benevolent and civic minded. Stratton lived in Colorado Springs where he did much to improve the city including the revitalization of the trolley system.